SEEING AND
PAINTING THE
COLORS OF NATURE

Joseph and Gloria Dawley

SEEING AND PAINTING THE COLORS OF NATURE

Watson-Guptill Publications/New York

My thanks and appreciation to
Kathleen DeBlasio and Sara
Pender, without whom this book
would not have been possible.

DAWLEY

Edited by Brigid A. Mast
Graphic production by Hector Campbell
Set in 11 point Goudy Old Style

Copyright © 1987 by Joseph and Gloria Dawley

First published in 1987 by Watson-Guptill Publications,
a division of BPI Communications, Inc.,
1515 Broadway, New York, N.Y. 10036

Library of Congress Cataloging-in-Publication Data
Dawley, Joseph.
 Seeing and painting the colors of nature.
 Includes index.
 1. Painting—Technique. I. Dawley, Gloria.
II. Title.
ND1500.D384 1987 751.45 87-23032
ISBN 0-8230-4761-X
ISBN 0-8230-4762-8 (pbk.)

Printed in U.S.A.

Paperback Edition
First Printing 1993

 2 3 4 5 6 7 / 99 98 97 96 95 94 93

This book is dedicated to Nancy and Terrie Brown—two fellow artists and fans of my art, who for many years have worked tirelessly to help create awareness of my name around the country.

CONTENTS

Introduction

Until August 1982, I was a full-time artist painting in the traditional realist style. I had developed a reputation as a realist painter, and Watson-Guptill had published four of my books, all dealing with the techniques of this style. I had no intention of changing styles at that time.

Since 1975, I had been suffering from Parkinson's disease, which was becoming progressively worse and more disabling. By 1982, although I was being treated with medication, I was only able to work one and a half to two hours a day. A surgical procedure was suggested that offered a good chance of greatly relieving my symptoms. In 1982, I opted to have the surgery. I assumed that after recovery I would be able to continue with my career as a traditional realist painter. I had no idea my whole life was about to change.

The surgery was a success in that my Parkinson's symptoms were significantly relieved. An unexpected complication occurred, however, that was almost more than I could handle under the circumstances: I lost a large degree of fine motor control and dexterity in my right hand, which is my painting hand. The realization that I was still unable to paint in my chosen style, in spite of the success of the surgery, left me in a state of constant depression and despair.

It was at this point that my wife decided enough was enough. Wallowing in self-pity was simply not going to be acceptable—especially when I now had the physical ability to paint and merely lacked the tight control required for traditional realism. She prodded me into a looser style, impressionism—a style I had always liked but had never seriously pursued. This technique was perfect for me because it involves placing one brushstroke next to another, rather than meticulously blending and modeling. I was perfectly capable of handling this.

My first efforts were truly pathetic. My mind knew what I wanted to paint, but my hand didn't have enough control to carry through. No matter how bad the results, however, my wife and friends found something positive every time and praised and cheered my efforts. This encouragement spurred me on, and the more I tried, the more my control returned, slowly but surely.

After many weeks of struggling, I became supremely motivated when my art dealer, who handles my work, came to my house to see the new works (scared to death, I later learned, by what he might see), and was surprised and pleased by my new paintings. Shortly thereafter, he put them in a one-man show, and we were all ecstatic to see that the public responded with enthusiasm to the new style. I knew then that my friends and loved ones weren't just patting me on the back; I really did have a new style that I could love and work with.

After a very long time, my control returned sufficiently for me to have a choice: I could return to traditional realism or stay with impressionism. By that time, I enjoyed impressionism so much that there was no question in my mind—I would continue in the impressionistic style.

Not only did my technique go through a radical change, but my whole approach to the selection of subject matter had to change dramatically. In my traditional works, I usually painted people with objects, or occasionally objects alone. In either case, I used a traditional dark background. I realized that everything had to change if the new style of painting was to work consistently for me. My conception of subject matter had to change from objects to scenes. This was much more difficult than it sounds. I had spent my entire life up to this point looking for specific things—interesting-looking people, old boats, unusual placements of items, doorways, windows. Now I had to leave the specifics and search for the general overall scenes. Changing a lifelong attitude as to what's exciting and beautiful is a very slow—but unbelievably exciting—process. My wife and I would go to the same areas we had gone to in the past, but with the change in perspective, it was like seeing an entirely different location. In the past, for instance, we might have gone to a harbor in search of an old, rugged fisherman and an interesting old fishing boat or dock; revisiting the same scene for motifs for the new style, we would be looking for the entire vista instead of the specific elements within it. Places we previously thought had no subject matter were suddenly loaded with it. Of course, this also worked in reverse.

During this extensive learning process, I started looking at the hundreds of photographs I had taken for the traditional paintings. Just as the way I viewed a scene had changed, the way I viewed the photos changed also. Instead of looking for a particular item of interest in a photo, I had to look at the larger scene—either the whole or a large part of it. This was a wonderful realization, because now I had reference photographs that could be used in new ways. I saw how I could mix and match not only objects (which I had already done) but entire segments of scenes, incorporating other objects if I desired, and that is essentially what this book is all about.

Imaginative painting is not something that is new to me—I have been doing it for many years. I learned very early in my career that searching for the perfect subject matter could waste many hours that might otherwise have been productive. Often I will establish the general concept of a subject matter in my mind, then set about filling in the missing pieces to create what I want instead of having to settle for just what is really there. I can also go about with nothing particular in mind, see the germ of an idea, and be able to create around that. I have always felt that this technique encourages a high degree of imagination, design, and creativity, which are basic to good painting.

Let me say in closing that after a lifetime of the traditional approach to painting, a smattering still invades some of my work. Sometimes I still integrate the traditional technique by blending a little here and there. It's done by choice and often that very combination of the traditional along with the impressionistic produces the very result I'm seeking.

Traditional Style: Forms Are Defined by Values

This is an example of my earlier, traditional style of painting.

The colors are subdued; everything fades into darkness at the bottom. In traditional painting, I worked mainly with values, that is, with light and dark; in impressionist painting, I work more with color.

Forms in this painting are defined by changes in value; colors do not change much across a surface. There is a lot of tinting, lightening areas by mixing white with the colors, and glazing, darkening areas with transparent washes of dark colors. Brushstrokes are blended carefully so they are almost invisible.

If I were to repaint this scene impressionistically, I'd use more colors, placing different colors side by side and letting the brushmarks show. The dog in this picture, for instance, is mostly black and white; if I were painting him now, I'd use brown colors but put in a little ultramarine blue in the shadowed parts and maybe some cadmium orange in the light. I'd handle the wood paneling differently, too. Here it is mostly raw umber and black, and it looks very much like wood. Now I'd look closer to see what other colors are in there—I might put in some mauve, some green—everything but the kitchen sink.

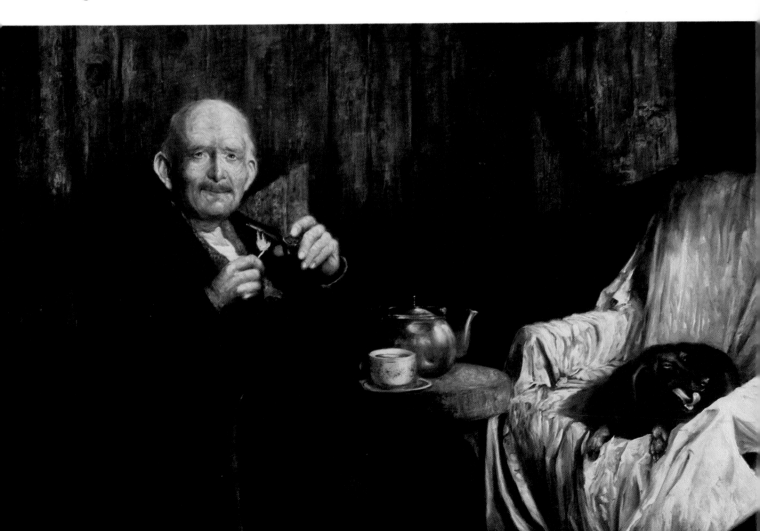

A Nap in the Attic, oil on Masonite, 36″ x 48″ (91.4 cm x 121.9 cm)

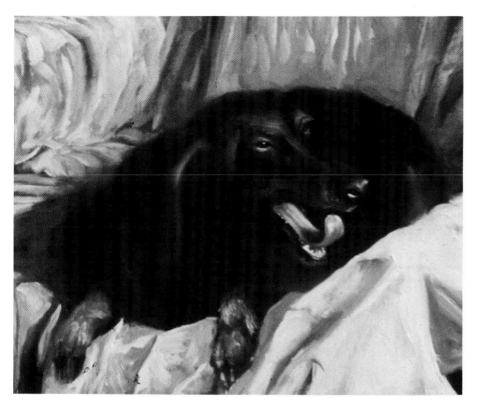

The dog in this very traditional painting is rendered mostly in black and white. His form is defined by changes in value—his dark silhouette, the highlights and shadows on his fur.

This dog, from the painting The Doll House II, *on page 29, is painted in a more impressionistic style. I used blue and purple in the darkest areas and yellow and white for the light. Color, as well as value, defines form.*

Start with the Center of Interest

This is a good example of how you can start with your central area of importance and work it into a painting.

The three men were not only the main thrust of the painting but also the most difficult part to render. I felt it would be easier to adjust the rest of the painting to the perspective of the men than vice versa.

The three figures came from photographs taken on the spot; they were not together in the photos, however, so part of my task was to bring them together as a group. I had to pay careful attention to their proportions relative to one another, the way they are standing, their facial expressions. The central figure anchors the group; his clothing is relatively uniform in color and value, but his cap is the lightest area in the whole painting. The blue-gray of his jacket is picked up in the folds of his companions' jackets, helping to tie the group together. Note that the men's jackets are yellow, blue, and red—the three primary colors.

Once I was happy with the central group, I added the rest of the scene, working from photographs once more. The men are coachmen at St. Peter's Basilica—hence the coach in the foreground and the basilica in the background.

I was still working in the traditional style here; the colors are subdued and forms are defined more by value changes than by color. I used a lot of black in this painting, something I would never do in my impressionist work. Traditional doesn't have to mean tight, however: The background figures are rendered loosely, and their indefiniteness of form helps push them into the distance and define the space between the main group and the basilica.

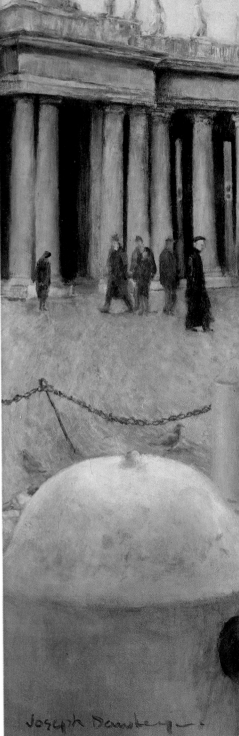

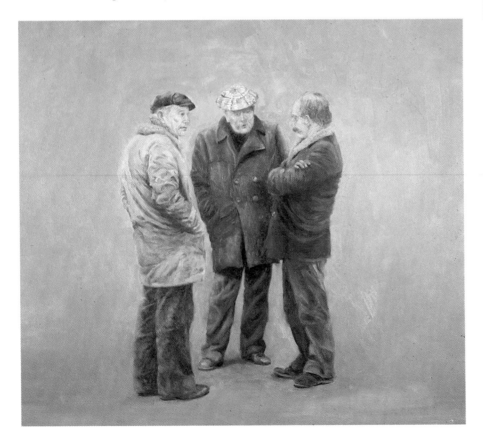

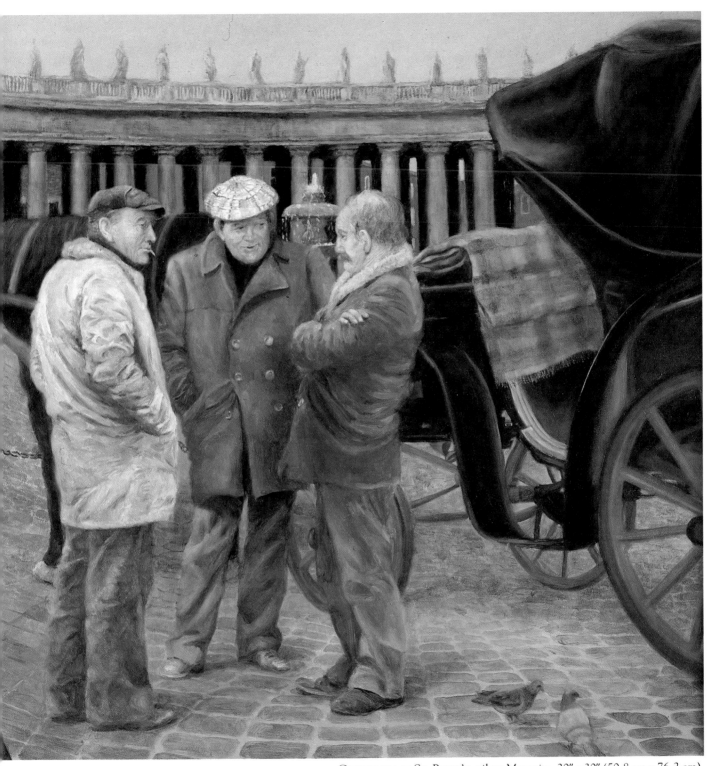

COACHMEN AT ST. PETER'S, oil on Masonite, 20″ x 30″ (50.8 cm x 76.2 cm)

Simplify Compositions by Grouping Values

This painting was composed from the two photographs reproduced here. Photo A, which contains most of the scene, is very cluttered; I had to simplify the composition a great deal. The painting is done in a traditional style; the colors are blended smoothly, and I did a lot of tinting and glazing.

I began with an intricate drawing, then painted in the background as a large, flat area of a single color. Next, I added the figures and the table. Note that the lightest areas of the canvas are in the foreground figure; this brings him forward and establishes his importance in the composition. I lightened his jacket quite a bit, compared to the photograph, strengthening the folds, giving it color, making the light dance off it. The light and warmth of this figure are very important to the mood of this painting.

The onlooker was taken from photo B; in order to integrate him into the scene, I repositioned him slightly. I had to be very careful that the lighting on both men was the same, so I increased the light on the second figure. Since much of his face isn't visible in the photograph, I had to make it up. I also altered his clothing so that it would be more appropriate.

After I finished the figures and the table, I painted the wheel. This was very difficult because the spokes cross the face of one figure.

Once the main masses and values were established, I could turn my attention to the background. Some of the elements were in the original photo; others, like the key ring, I made up. In order to give the painting greater coherence, I kept the background simpler and more subdued than that of photo A.

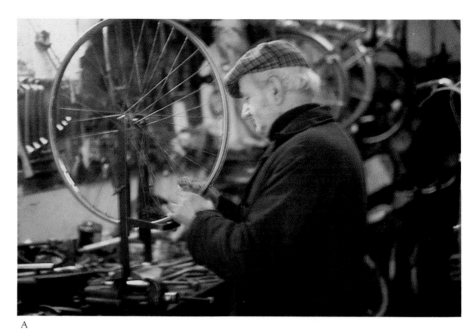

A

B

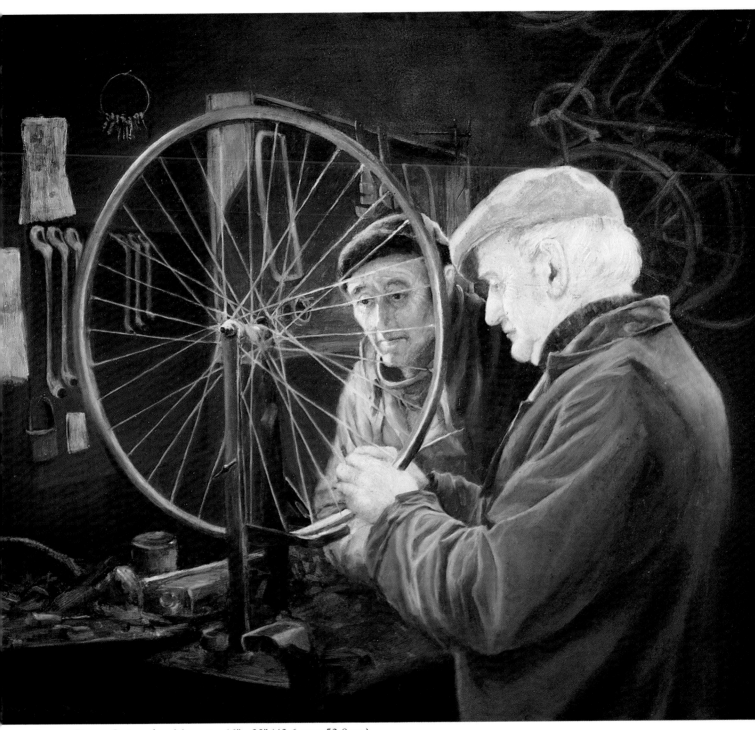

BICYCLE REPAIR SHOP, oil on Masonite, 16″ x 20″ (40.6 cm x 50.8 cm)

Changing the Composition to Suit the Style

These two paintings, although of the same subject, couldn't be more different. One is smooth and elegant; the other explodes in a riot of colored brushstrokes. I was looking for a different effect in the impressionist painting, and I changed the composition to accommodate the style.

The traditional painting on the left came first; it was carefully planned, and the figures, flowers, and background were assembled from several different photos. The main thrust of the composition consists of two diagonals (see diagram) that cross the canvas. The eye is led along each by areas of bright color, light value, and high contrast, as well as by the gestures of the figures.

It seems natural, for instance, to follow the gaze of the vendor to the bright flowers in his upraised hands; then the light pink bouquet in the upper right corner catches the eye. The center of interest is the central area of the painting, which contains the whitest whites and a lot of interesting small shapes. As the eye moves from the center of the paint-

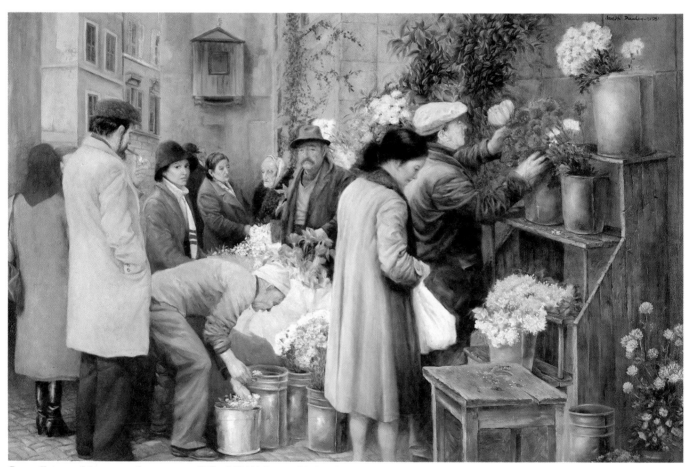

Rome Flower Market, oil on canvas, 24" x 36" (61.0 cm x 91.4 cm)

Bright colors, light values, and strong contrasts lead the eye across the canvas along two diagonal paths. Strong colors and values are grouped in the center of the canvas.

ing to the edges, contrasts become more subtle and colors more subdued. Compare, for instance, the yellow flowers on the table with those in the lower right corner. While the flowers add color and interest, this painting is basically an interesting arrangement of figures.

When I repainted this scene in impressionist style, I changed the dominant subject matter from figures to flowers, the better to exploit the impressionist palette and brushstroke. I eliminated some of the figures and pushed the remaining ones back, allowing flowers to fill the foreground. I also changed the background buildings to give a sense of deeper space. The basic X of the composition is still there, but it is not as assertive and has been pushed down a bit. The eye follows the edge of the flowers. The central area doesn't dominate the painting; intense colors and bright whites are distributed all over the canvas.

Most important, the new composition freed me up to concentrate on the brightness of the flowers and the glow of the paint.

FLOWER MARKET IN ROME, oil on canvas, 24″ x 36″ (61.0 cm x 91.4 cm)

The composition is simplified by removing several figures and weakening and pushing down the X. The flowers, which lend themselves to the bright colors and broken brushstrokes of impressionism, take over the foreground. The center of interest is no longer confined to the center of the canvas; bright colors and light values are distributed more evenly.

Changing the Composition to Suit the Style

These flowers in the traditional version of the painting are rendered in clusters of separate brushstrokes, but there is little color variation within the forms. Value changes—from darker to lighter yellow, from cool gray to bright white—shape the forms.

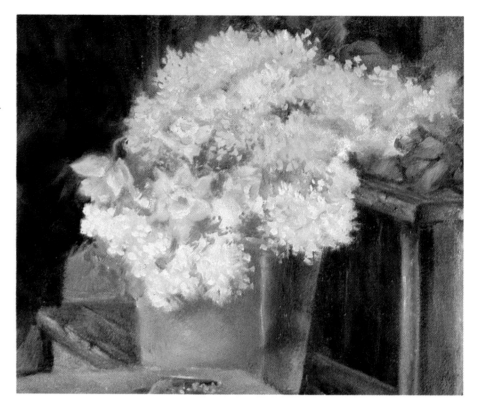

The brushstrokes have broken free of the petal forms and float on a sea of color. While they still convey the sense of a bunch of white and yellow flowers, the boundaries are blurred. Touches of red, green, and violet add richness to this area.

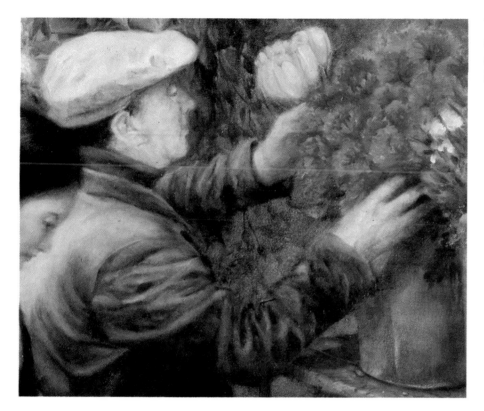

This figure is carefully modeled in light and dark tones. The illusion of three-dimensionality is strong, but there is little variation in color.

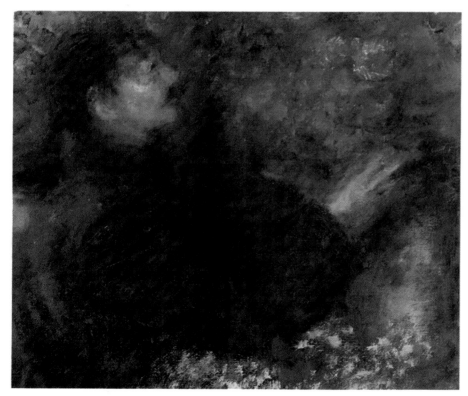

Brushstrokes and flecks of color animate this figure and his surroundings; he almost seems to be moving.

A Muted Palette Uses Broken Color

The colors in this painting are subtle but varied. This is a transitional painting: I have begun using broken color, rather than tints and glazes, to describe forms, but I haven't moved fully into the impressionist style yet. The figures are still carefully modeled, some colors are blended, and I'm still using some black.

The broken-color technique enables me to create an area of low-key color by placing small brushstrokes of fairly bright colors side by side. The vegetables in the left background, for instance, are painted with spots of red, green, and yellow in one place and purple, green, and brown in another, but the bright colors do not stand out. Instead, they are optically blended; that is, the viewer sees them as one fairly neutral color rather than several bright colors. I could have just mixed the components on the palette into one solid gray, but the effect produced by broken color is much richer and more interesting.

I have also begun to use color to define form. The shadows on the bins to the left, for instance, are purple, and pale green highlights make the poles in the background stand out. The sleeves and hands of the man holding the cauliflower are shaped by yellow highlights; this same yellow sparkles on the vegetables, the scale, the shopping basket, picking out forms and pulling the scene together.

Most of the values in this painting fall in the middle of the range, although there are some very dark areas. The only bright white is the cauliflower in the center of the canvas. Strong value shifts are no longer necessary to create the illusion of three-dimensionality.

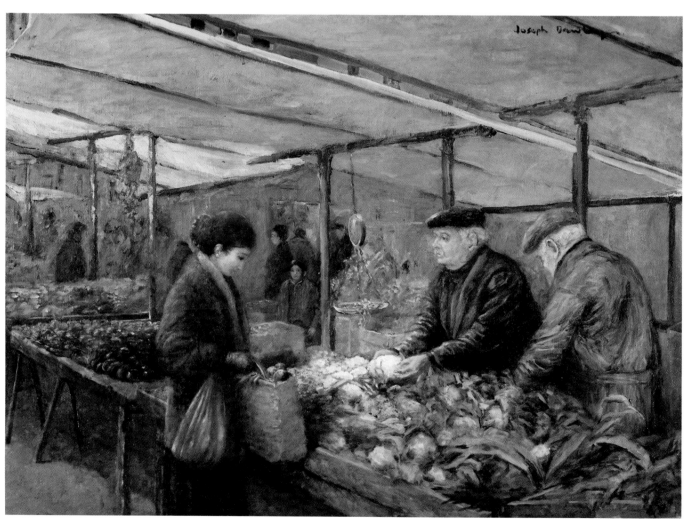

VEGETABLE MARKET, oil on canvas, 18″ x 24″ (45.7 cm x 61.0 cm)

Color and Contrast Define Space

This is the most colorful of my traditional paintings. The hues are very saturated and the contrasts are very sharp.

The perspective draws the eye into the scene—see how the bins of fruit seem to be tilted toward the viewer—but it is the warmth of the colors, and their intensity, that really makes them come forward. The dull greens, the gray jackets, and the woman's black coat surround and isolate the brilliant colors and push them forward. Less intense, but still warm enough to stay in the forefront, are the flesh tones

and the boy's jacket. The blue shirt and the purple scarf stand out because of their intensity and provide a link with the cooler hues of the background.

The colors here are carefully blended. The oranges, for instance, have white highlights and bluish shadows, but the color changes are gradual and subtle, and no discrete brushstrokes are visible. If I were doing this painting impressionistically, I'd leave the colors separate—a spot of white or bluish white as the highlight on the top; maybe some blue on the bottom, in the shadow.

Rather than blending the colors into smooth transitions, I would let them sit side by side. This would key up the color intensity even higher and, by heightening color contrast, bring the oranges even farther forward.

Areas of strong contrast also attract the eye and thus seem to jump forward; here, the line where the woman's white shopping bag meets her black coat is the sharpest value change in the whole picture.

As the eye moves farther into the background, values become lighter and closer together, and hues become cooler.

MARKET PLACE—ROME, oil on Masonite, 20″ x 24″ (50.8 cm x 61.0 cm)

Darks Without Black

Part of this scene also appears in the background of *Market Place—Rome* (page 21); the group there appears more or less as in the original slide. When I decided to paint the three men, I eliminated the background figures and shifted the trio slightly to set up an interesting pattern of lights and darks. On the left, the boundary of the group is defined by the line of contrast where the contour of the left-hand man overlaps the darkness of the doorway. The dark tie on the white shirt of the man in the center draws the eye toward the middle; his light gray suit overlaps the dark area of the farther door. The face of the third man stands out sharply against the doorway; his coat

is closer to it in value, so this area has less contrast. Note how his contour on the right becomes more and less distinct as its value varies with respect to the background.

This painting has a wide range of values and some interesting value shifts, but it contains virtually no black. I use very little black in my impressionist work because the color is so intense. Sometimes I'll use a mixture of, say, ultramarine blue and mauve, rather than using black from a tube. I also use combinations of ultramarine blue and yellow ochre, applied in broken-color fashion, for the dark areas.

Eliminating black from my palette makes for much more exciting color. Many of the shadows, particularly in

the clothing, are modeled with blue, so that a change in color, as well as value, defines the form. The difference is most noticeable in the large dark areas in the doorways. In the earlier version, the black is so flat, and the change in contrast so great, that these areas look like "holes" in the picture—the black is jarring. In the impressionist painting, the darkness is multicolored—it is made up of several colors that can be seen separately but combine to create an overall impression of darkness. Not only is this more lively than flat black, but it picks up the other colors in the scene, strengthening the relationship between the doorway and the rest of the painting.

The use of black gives a totally different character to this earlier, more traditional rendering of this scene. While the pure black gives rise to crisp, pleasing contrasts, it also disrupts the sense of space and deadens the dark areas.

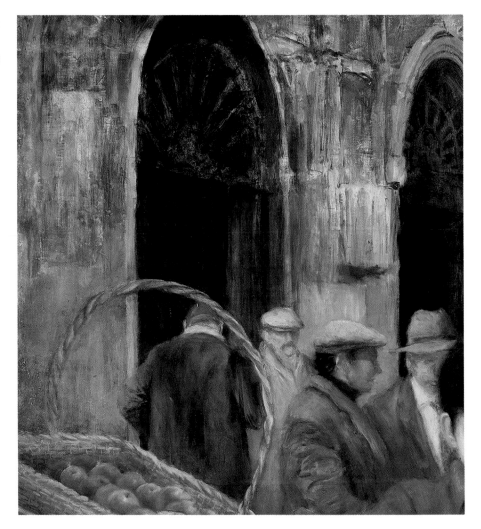

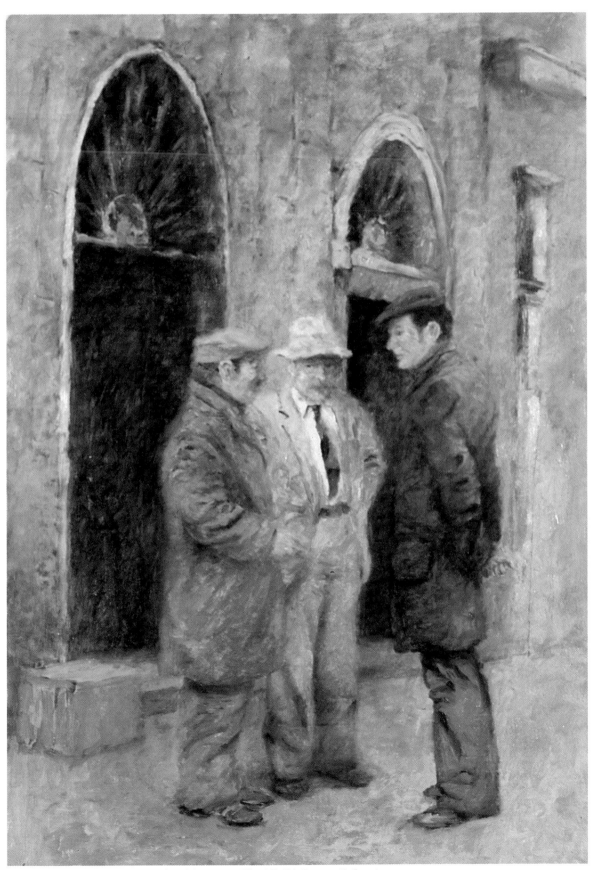

THREE MEN AT THE PORTICO, oil on Masonite, 12″ x 16″ (30.5 cm x 40.5 cm)

Colors Shift to a Higher Key

The traditional painting is practically a study in blacks and browns; it contains very little bright color and relies on its value structure: crisp whites, deep blacks, and strong light effects. There's a lot of glazing and tinting in this painting—the shadows in the man's coat and pants, for instance, are all done that way.

The brushstrokes I use in impressionist paintings are small and discrete—small strokes of different colors lying next to each other, rather than the careful blending of traditional painting. This technique, when used with the impressionist palette, results in complex and vibrant colors. Here, yellow lies next to red, red next to blue. Purples and blues reverberate throughout the painting. All the dark umber tones in the traditional painting have been muted to pale, soft, pastel-like colors.

I changed the picture somewhat when I repainted it. I increased the depth of the scene, thereby making the men less prominent, and I added the bowl of flowers in the lower right foreground to increase the sense of space. Of course, I changed the paintings on the wall to impressionist paintings; these, along with the vase of flowers and the Oriental rug, also provided more opportunities to use bright areas of broken color.

To add a touch of contrast, I left the paper drawing on the floor. This white area enhances the otherwise pastel tones of the painting.

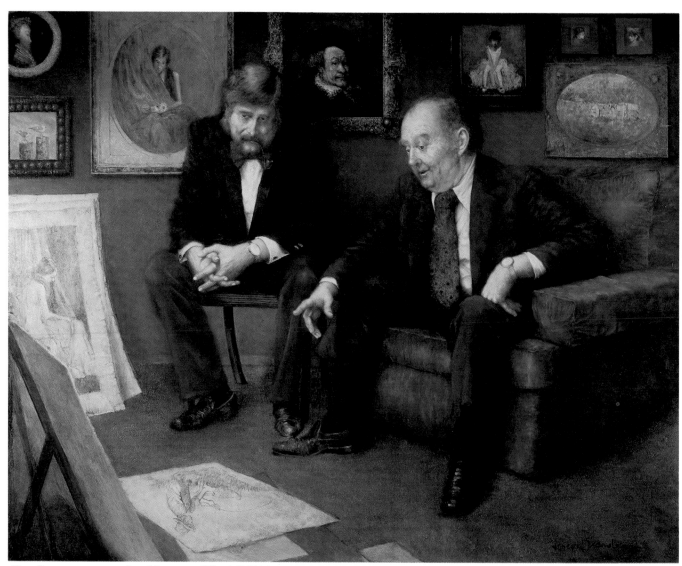

THE CONNOISSEURS, oil on Masonite, 30″ x 36″ (76.2 cm x 91.4 cm)

TRADITIONAL AND IMPRESSIONIST PALETTES

Traditional Palette
cadmium red medium
Venetian red
burnt sienna
raw sienna
yellow ochre
phthalo blue or Prussian blue
raw umber
ivory black
titanium white

Impressionist Palette
alizarin crimson
vermilion
cadmium red medium
cadmium red light
cadmium orange
cadmium yellow
yellow ochre
Naples yellow
chromium oxide green

sap green
phthalo green
cerulean blue
phthalo blue
ultramarine blue
cobalt violet
permanent mauve
titanium white

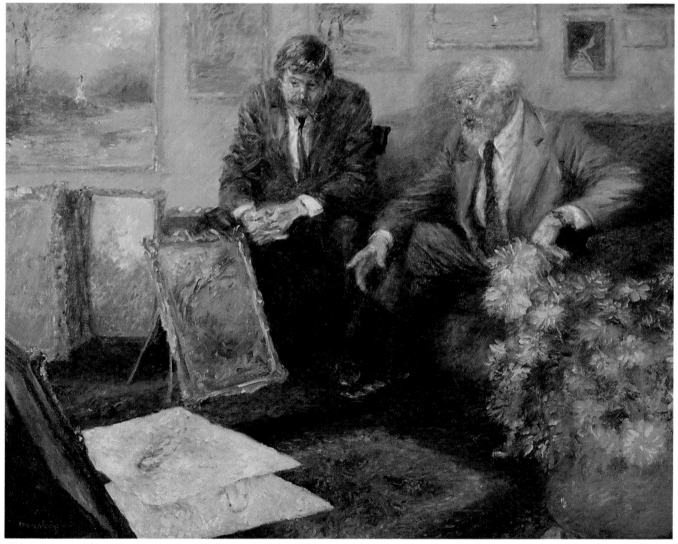

CONNOISSEURS' CHOICE, oil on canvas, 24″ x 30″ (61.0 cm x 76.2 cm)

Dark Tones and Broken Colors

This painting is a transition piece. When I did it, I still had a little traditional painting left in me, but I was more of an impressionist, so it contains elements of both styles—in a sense, it bridges the gap between the two previous paintings.

There are many passages of broken color in this painting— the loveseat, the figure (particularly his head), most of the background. Color changes are used to depict a complex form in the white statue at left and its reflection in the mirror. Sparkling highlights—in particular, those on the picture frames—entice the eye deep into the picture.

The palette, while brighter than many of my traditional paintings, is not yet as high-key as that of the full-blown impressionist style. There are many dark tones in this painting and, as in many of my traditional works, it fades off a bit into darkness at the bottom. There is a little glazing as well.

There is almost no pure white in this sculpture, although it registers as white to the eye of the viewer. Shadows are blue, purple, gold, orange. This area was originally covered with a bright red underpainting; because of the texture of the canvas and the looseness of the strokes, some of the red still gleams through, enhancing the already vibrant colors.

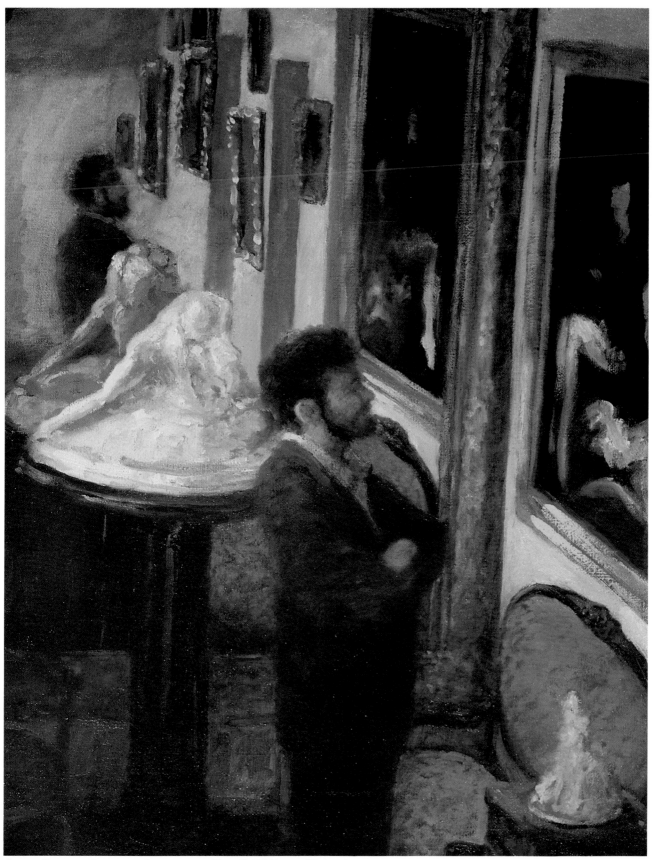

INSIDE CALVERT GALLERY, oil on canvas, 18″ x 14″ (45.7 cm x 35.6 cm)

Broken Color Enriches Flesh Tones

In many of my traditional paintings, I used Venetian red, maybe with a little yellow, for the flesh tones. Venetian red is an earth color; it is fairly dull, but it is the brightest red I would use in a skin color. In the traditional version of this painting, the girls' skin is painted in this low-key color; there is little color variation in the shadows and highlights, and the brushstrokes are carefully blended.

In the impressionist version, I used stronger colors—cadmium red medium, cadmium red light, some blue in the shadows. The brushstrokes are small marks of pure color placed side by side and blended only slightly. The marks remain separate on the canvas but are optically mixed by the eye of the viewer; this allows for rich, varied color. Rather than working with lighter or darker shades of Venetian red, I might put down a streak of blue on the canvas, then a little brushmark of alizarin crimson next

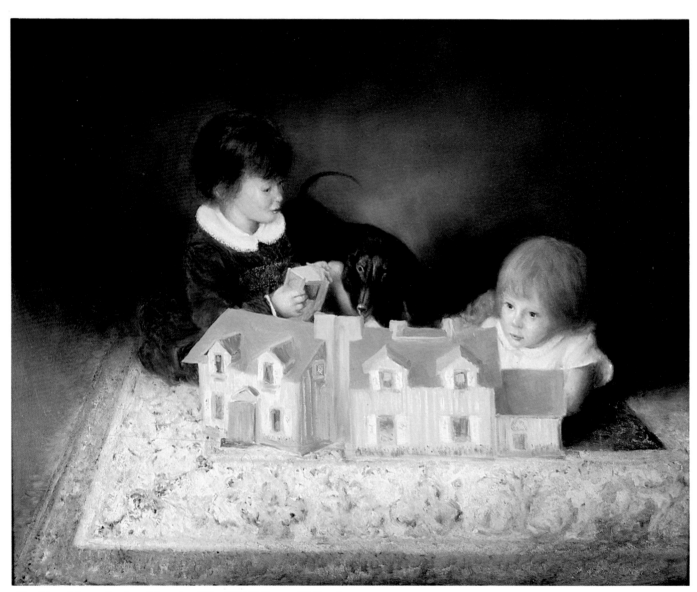

THE DOLL HOUSE I, oil on Masonite, 16″ x 20″ (40.6 cm x 50.8 cm)

to it, then maybe a little yellow ochre or white, so the flesh tones are not one color but many colors.

I changed this scene somewhat when I repainted it. I felt the smooth background wouldn't work with an impressionist style, so I put in the fireplace, which not only provided a definite light source but also, along with the stonework, presented a marvelous vehicle for the use of broken color. Note how the colors of the fire are picked up in the rug and in the redhead's hair.

Another reason for adding the fireplace was to change the composition by increasing the depth of field. For the same reason, I moved the dollhouse forward. In the traditional painting, the central area of the canvas is the center of interest; the impressionist painting is more dispersed. One of the advantages of eliminating a strong focal point is that the viewer's eye can travel freely across the painting rather than locking on one strong area.

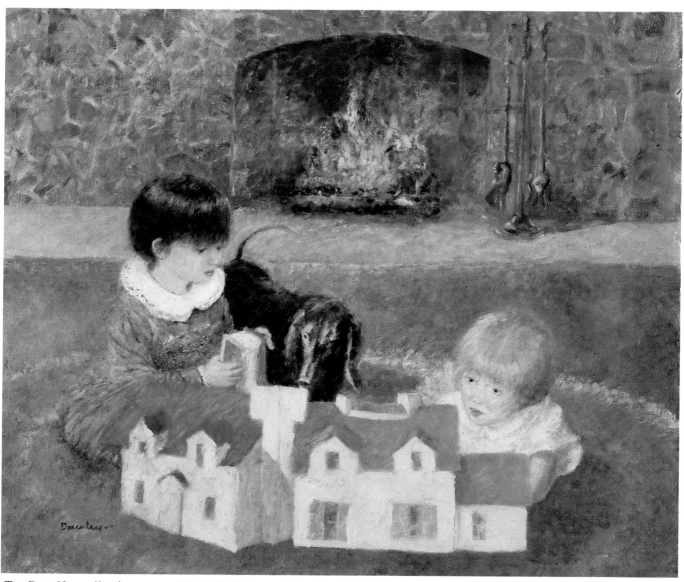

THE DOLL HOUSE II, oil on canvas, 20″ x 24″ (50.8 cm x 61.0 cm)

Using White as a Vehicle for Light

I used a great deal of white in both these paintings, but I handled it differently to get different effects.

In the traditional painting, the large, light areas of sky and water convey the feeling of a cool, overcast day. The sky is a pale, cool, almost colorless gray; the puddles carry this coldness into the lower half of the painting. A great deal of white is used in these sky and water areas; it is relatively flat and carefully blended to depict the diffused light of an overcast day.

The higher-keyed, slightly warmer palette of the impressionist painting indicates a sunny day. Here, the white is not blended at all but dances in small highlights that lie on top of the other colors and convey the sparkle of the water.

In each case, the use of white was appropriate to the composition and color scheme of the painting. The traditional painting uses small details and large areas of color; in addition to the sky and water, the dark, wet sand adds to the chilly feeling. The figures command a great deal of attention, but small details, such as the pebbles and the dark reflection of the bucket, add interest to the periphery of the can-

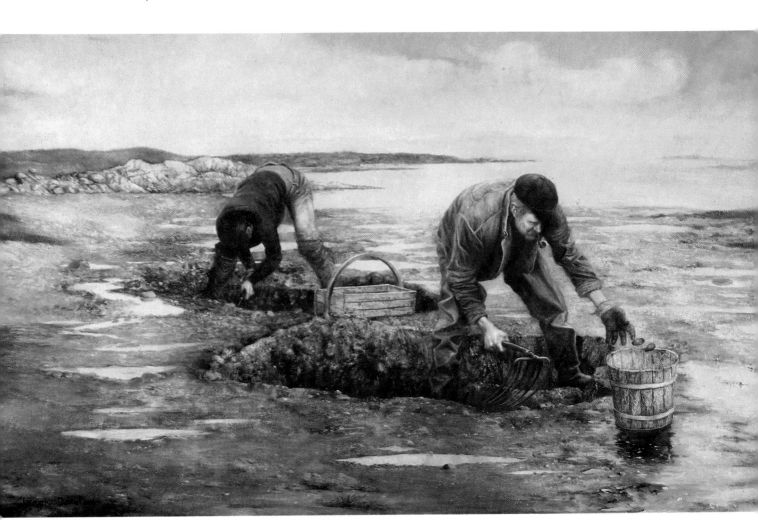

CLAM DIGGERS I, oil on Masonite, 20″ x 30″ (50.8 cm x 76.2 cm)

vas and reinforce the sense of place. This is, in many ways, a very specific painting.

In keeping with the weather, the colors are cool and low-key. I used ultramarine blue and phthalo blue, with a little black in places; greens were mixed from phthalo blue and yellow ochre; the skin tones were burnt sienna with Venetian red and a little cadmium red.

When I reworked this subject, I shifted the perspective and pulled back in space so the group of clammers was no longer the focal point of the painting. The overall impression is important here; this painting is general rather than specific. The figures blend into the space rather than stand out. This allows a freer use of loose brushstrokes.

My palette has changed dramati-cally. The colors are cool but much more intense. The predominant colors in the water are cerulean blue, ultramarine blue, phthalo blue, and white, applied in broken-color fashion. I also used permanent mauve, ultramarine violet, cadmium red light, cadmium red medium, cadmium orange, cadmium yellow, chromium oxide green, and ultra-marine violet.

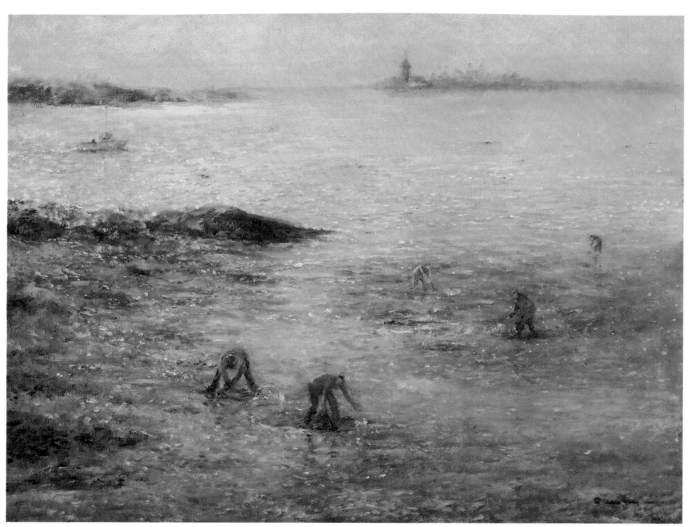

CLAM DIGGERS II, oil on canvas, 20″ x 24″ (50.8 cm x 61.0 cm)

Using Color Imaginatively

hotograph A, which I used for most of this painting, is rather dark and dull. I decided to brighten it up and bring in more interesting colors.

I knew that the scene was going to be lighter overall than the photo, so I made the sky much lighter. This directly affects the reflections in the water and indirectly affects almost everything else.

I brought the stand of trees forward, keeping the basic forms of the photo but using a greater variety of colors and values to describe them. I mixed several greens and yellows and applied them in broken-color fashion, using a little violet and brown here and there to bring down the intensity of the color. I used duller greens for the reflections in the water. The clump of seaweed in the lower left corner is the brightest green of all, because it is so far forward.

I didn't want to use a flat gray for the sand and rocks in the foreground; this seemed an ideal area to exploit broken color to the fullest. I used cool colors—violets, blues, greens—along with a little brown and some white and yellow to adjust value and intensity. The idea was to keep the individual colors bright but the overall effect fairly neutral.

The blue of the water is a little on the green side, to fit in with the overall tonality of the picture. I took the middle-ground figure from photo B. Note that the shadows on this figure are blue-violet; this effect often occurs on sunny days. I needed a figure in the distance to increase the sense of depth in the painting, so I simply made one up.

This painting is a good example of how you can bring exciting color into a painting—amplify what is already there, as I did with the trees, or experiment with new colors to find out what works best, as I did with the sandbar.

A

B

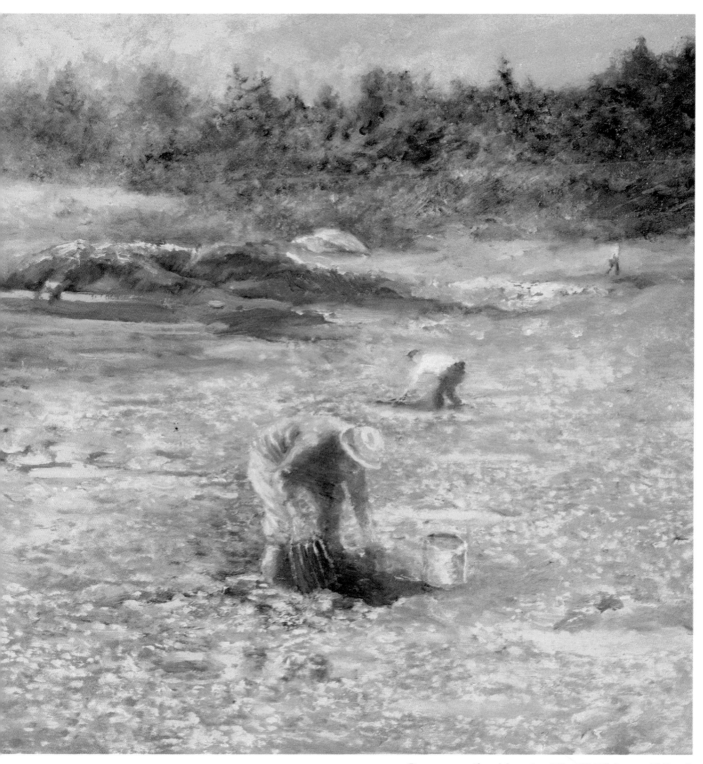

CLAMMERS, oil on Masonite, 14″ x 18″ (35.6 cm x 45.7 cm)

Handling Edges in a Variety of Ways

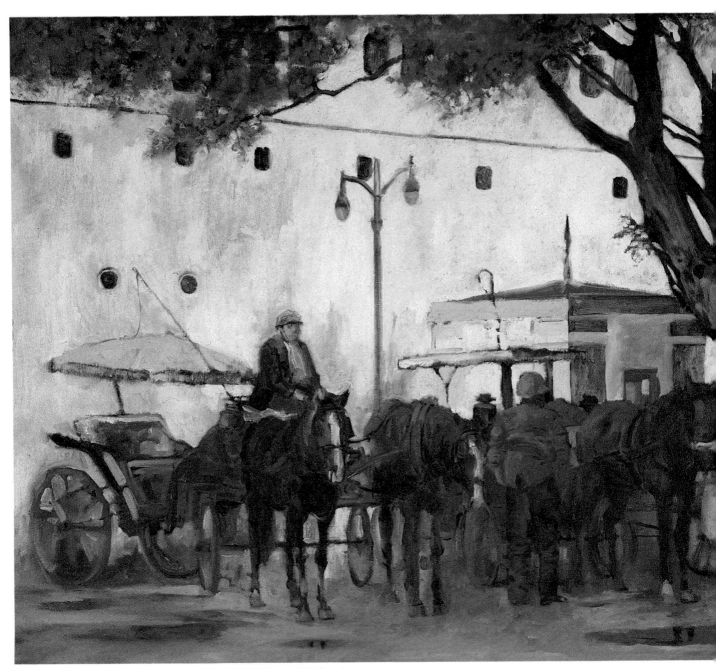

BERMUDA CARRIAGES, oil on canvas, 30″ x 48″ (76.2 cm x 121.9 cm)

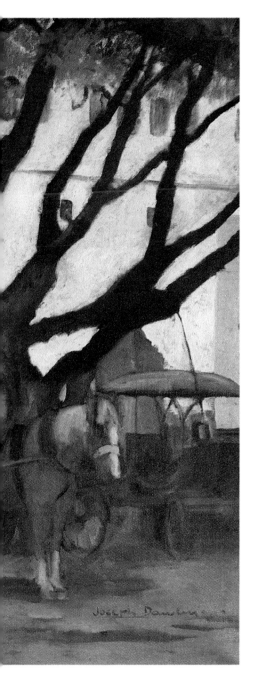

The subject matter of this painting may not be immediately obvious: It is a ship that has just docked at Hamilton, Bermuda; the carriages in front of it are awaiting fares from among the disembarking passengers. The side of the ship provides a luminous white background that, while not totally flat, is much more consistent in color and value than the sky would be. Because it takes up most of the background and is the lightest value in the painting, many of the forms are defined by their silhouettes.

There is actually quite a bit of variety in the way edges and contours are handled here. The tree branches are sharp and emphatic; the leaves are blurry and less distinct. The pink areas on the left side of the small building are so light that they are almost indistinguishable from the background. On the right side, which is in shadow, the contrast is clearer. I wanted the pink umbrella on the left to retain its light value without disappearing

into whiteness, so I used a thin, dark line to define its contour. I started out with a dark shape and covered it over with the pink, leaving just enough of the darkness to define the form. The dark line of the coachman's whip lies under the pink paint where it crosses the umbrella but over the white background.

When forms are described by their contours, the negative space in a composition becomes very important. Negative space is the "empty" space between things. In this painting, the negative shapes between the branches of the tree form a very pleasing pattern.

This was my first successful impressionist painting, and I painted much of it with my left hand. The palette is still somewhat dark, but the brushstrokes are freer. The carriage wheel on the left, for instance, is painted with a few loose strokes in a variety of colors; I have come a long way from the carefully rendered spokes of the bicycle wheel in *Bicycle Repair Shop* (page 15).

I painted this umbrella as a dark shape, then covered it over with pale pink, leaving just enough of the underpainting to define the form. This produces a nebulous edge. Note the variation in the line of the whip, which lies under the pink paint and over the white.

Colors Change the Mood of a Street Scene

I wanted this painting to convey the tranquility of early evening on a quiet street. The photo I worked from was taken earlier in the day, so I had to make some color and light changes to capture the mood I wanted.

Evening light is cool, bluish, so I shifted the colors toward that end of the spectrum. The buildings in this painting are more colorful than in the photo, but the colors stay cool or neutral. The building on the left, for instance, is yellow, which is usually considered a warm color. This yellow is colder than most, however, because it is grayed down. The blue doorway, with its even bluer shadows, adds to the effect.

The light coming from the windows, on the other hand, is a warmer yellow. The windows are handled very loosely, with a lot of warm color, so they will stand out against the shadowed facades of the buildings. Some of that warm yellow light spills out onto the sidewalk and street. The light falling on the trees is also cool, almost silvery.

In the photo, the trees cast a strong shadow on the street. I have muted that somewhat, in keeping with the diffused light in the rest of this scene. The colors in this area are very cool, with just a little warm light from the windows for contrast.

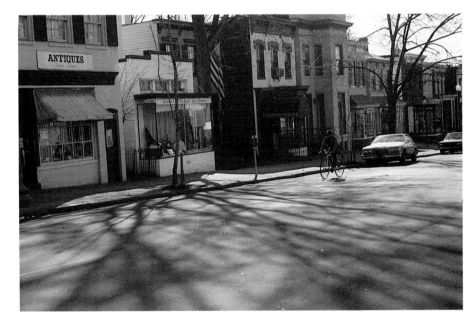

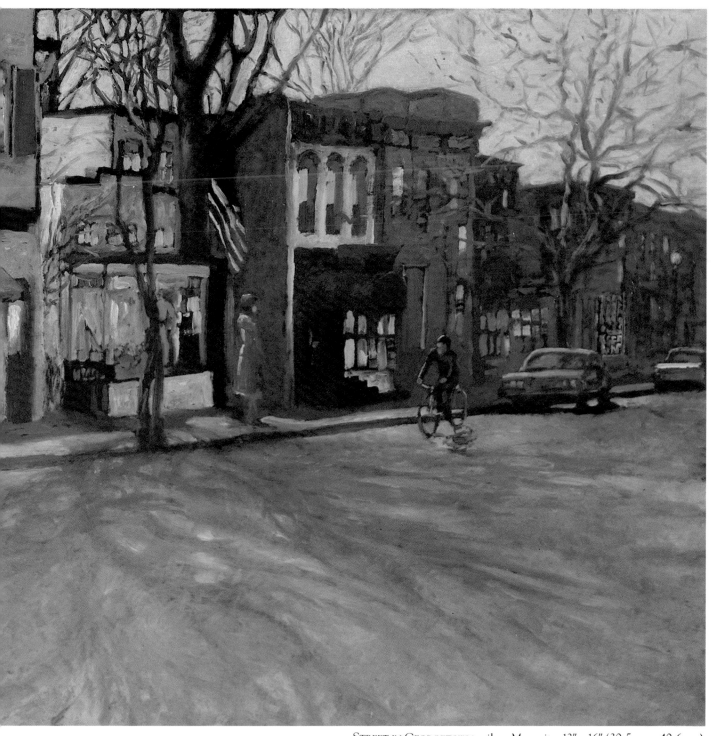

STREET IN GEORGETOWN, oil on Masonite, 12″ x 16″ (30.5 cm x 40.6 cm)

Large Brushstrokes Animate the Surface

Usually I paint with small, carefully placed brush-strokes, but once in a while a subject comes along that lends itself to large, gestural strokes. This was one such subject. I wanted to capture the overall flavor of the scene, rather than rendering details of architecture and tree branches, so I used loose brushstrokes to summarize the forms.

The facades of the buildings are defined by patches of light and color; sometimes the brush drags one color into or over another. In other places, such as the fence, the brushstroke makes a very simple statement—it becomes the object. Each post of the fence was painted with one stroke.

One key to successful handling of the large brushstroke is moderation—too much looseness can make your painting simply chaotic. Here, the relatively smooth surfaces of the grass and the concrete walls of the canal provide a respite for the eye.

I wanted to capture the motion of the water, so I concentrated on the little waterfall and on the movement of the water at the foot of the falls. I used a smaller brush here than in the rest of the painting, but the strokes are longer than usual. The technique I used here was to drag a brush loaded with white over a still-wet area of dark paint. I didn't go over the brushstrokes, as that would blur them and I would lose the crispness and the bristle marks.

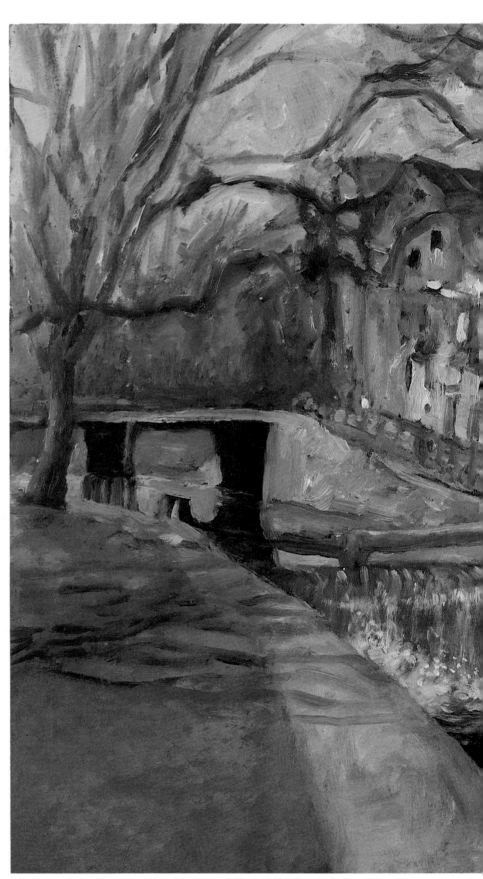

CANAL IN WASHINGTON, oil on Masonite, 20″ x 24″ (50.8 cm x 61.0 cm)

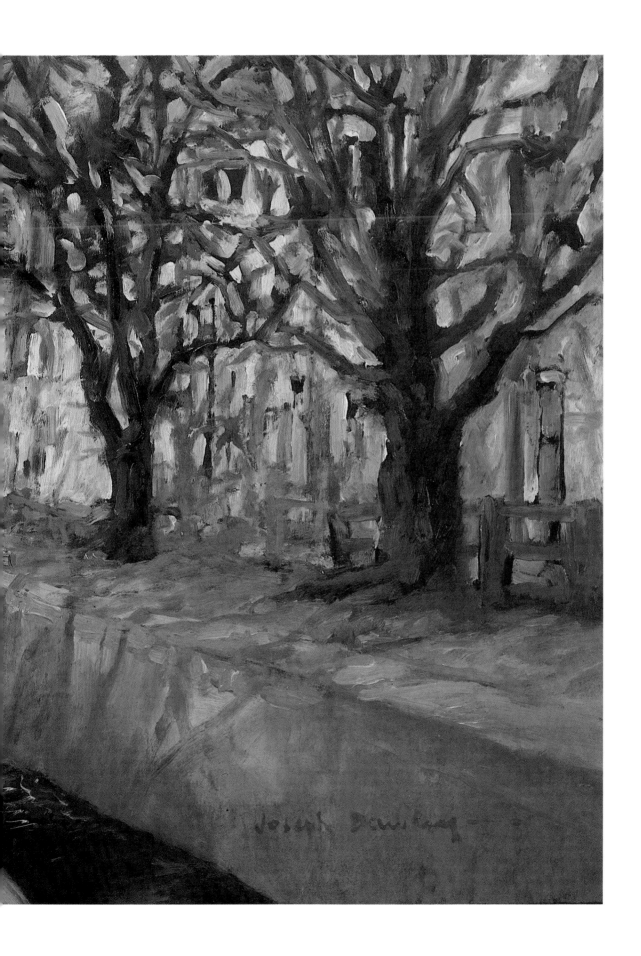

Painting Trees: Three Approaches

The silhouette of the tree in *Bermuda Carriages* (page 35) is very strong; the dark branches appear almost flat against the bright white background. There is some modeling in the trunk; I used light colors applied with loose brushstrokes for this. Because of my linear approach, the negative shapes between the branches stand out sharply.

In *Street in Georgetown* (pages 36–37), the near trees are sharply defined against the sky; their dark branches and clear contours create areas of strong contrast. There is very little modeling—just a few streaks of slightly lighter color, loosely brushed. The far trees seem to dissolve into the sky; I used lighter values and loose brushstrokes to achieve this effect.

Large brushstrokes, twisted shapes, and stronger colors make the trees in *Canal in Washington* (pages 38–39) seem to writhe on the canvas. Variations in color and value undercut the importance of the silhouette. Negative and positive space seem almost interchangeable: Are the branches in front of the light shapes, or vice versa? The looseness of the paint handling makes it hard to tell.

Dark branches form a strong silhouette against a white background. This tree is flat, linear; negative shapes are prominent.

The trees become less distinct as they recede into the background; the farthest ones dissolve into the sky.

Strong, sinuous brushstrokes and intense colors make these trees writhe on the canvas. The silhouette dissolves in the masses of color; positive and negative space seem interchangeable.

Composing a Painting in the Mind's Eye

I knew what I wanted this painting to look like: two cowboys traversing the river on horseback. Unfortunately, only one rider came by while I was at this site, and he didn't look much like a cowboy. I had to use my imagination and several photographs of related images to produce a whole that is greater than the sum of its parts.

I used photo A for the setting, but I zoomed in on the bend in the river and narrowed it somewhat, so it is more a stream than a river. This brought more of the far bank into the picture. I kept the background and the foreground vague, so they would be out of focus and not detract from the figures. The branch that juts out into the foreground

helps define the space, but I changed its value to a middle tone with a few highlights so it would blend into the trees and not attract undue attention.

The riders came from photos B and C—two shots of the same figure. I rendered them loosely, in keeping with the overall style of the painting; this also made it easier for

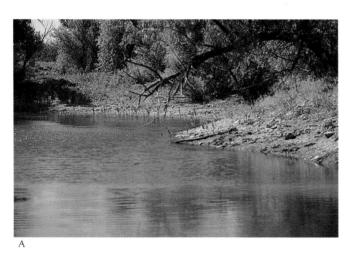

A

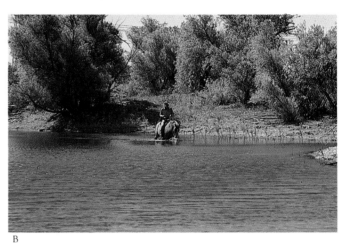

B

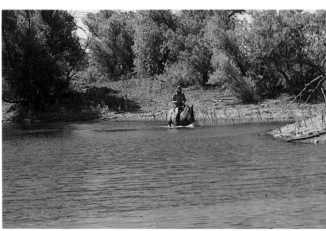

C

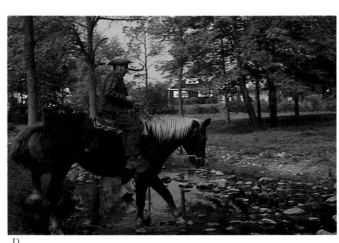

D

me to improvise. The near figure, who is based on photo C, presented something of a challenge. I just used the photograph for his general positioning, lowering his right hand a little and raising his left hand. This gave his hands an uphill tilt that complements the uphill movement of the horse. The horse itself is mostly my own invention, as it is largely underwater in the photograph.

I didn't like the clothing worn by the man in the photo; it didn't convey the mood I was trying to capture. The clothing worn by the cowboy in photo D was much closer to what I wanted. I used it more for inspiration than as a reference; the perspective of photo D is very different from that of the painting, and anyway, I didn't want the two riders to be identically dressed.

As is frequently the case, the water was a very important element in this painting. I brought in a lot of colors, making it much more lively than in the photos, and the shadows and reflections that fall across it add complexity to the surface and help unify the painting.

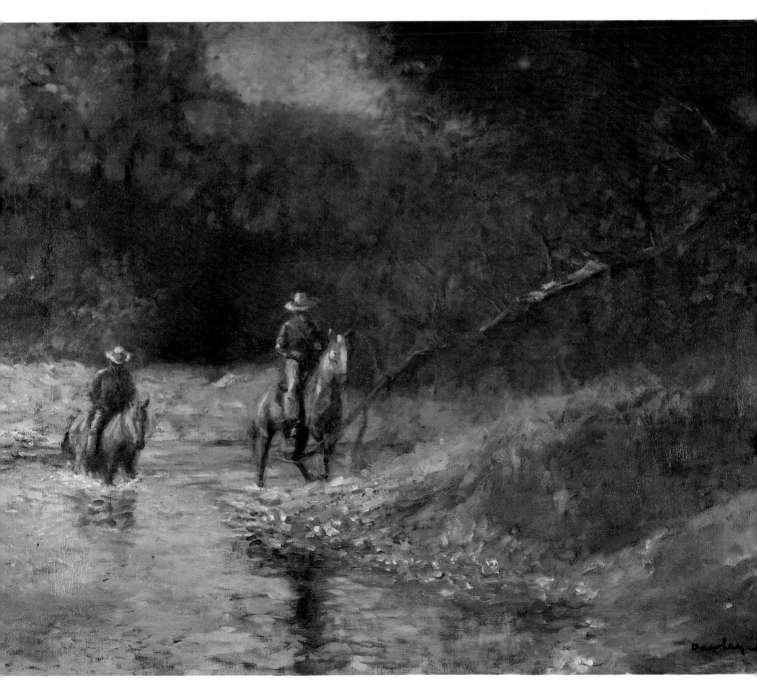

FORDING THE STREAM, oil on canvas, 24″ x 30″ (61.0 cm x 76.2 cm)

43

Making the Parts Work Together

The subject matter of this painting, horse trading on a breeding farm, had been suggested to me and described in detail. I had the scene firmly in mind when I set out to find the components. Three different photographs were used: the men on the left are from photos A and B, and the horse and his handler from photo C.

I began by casually blocking in all the elements. This is a very important step when you're painting from a number of photos, because you want all the pieces to be in correct proportion to each other. My next concern was the light; it had to be the same density overall, and it had to fall on all the figures from the same direction. In the photos, the cast shadows are very different; I didn't want to carry the inconsistencies over into the painting.

When I was sure all the elements worked well together, I turned my attention to completing the painting. The style is fairly traditional, although there are some impressionistic touches in the background. I applied the paint thinly, in the traditional manner, and I used quite a bit of blending and glazing, particularly in the figures and the horse.

My experiences with impressionism have influenced my traditional painting. Consider the horse. In my earlier paintings, I used value, rather than color, to define the forms; I would have used dark, probably black, glazes for the shadows on the horse. Here, however, I used raw umber, ultramarine blue, burnt sienna, ivory black, and raw sienna. The shadows have a bluish cast, while the lighter areas are a warm brown. I did render the horse very meticulously; I started out with a bristle brush but switched quickly to a no. 4 flat sable, which gave me a smooth brushstroke that blended easily.

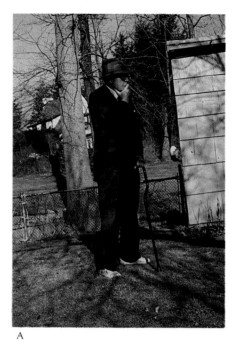

A

B

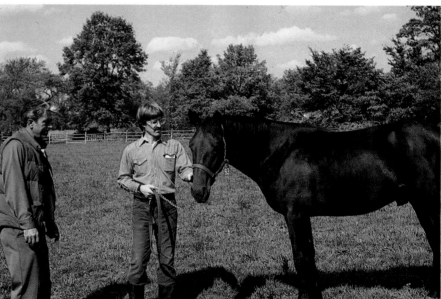

C

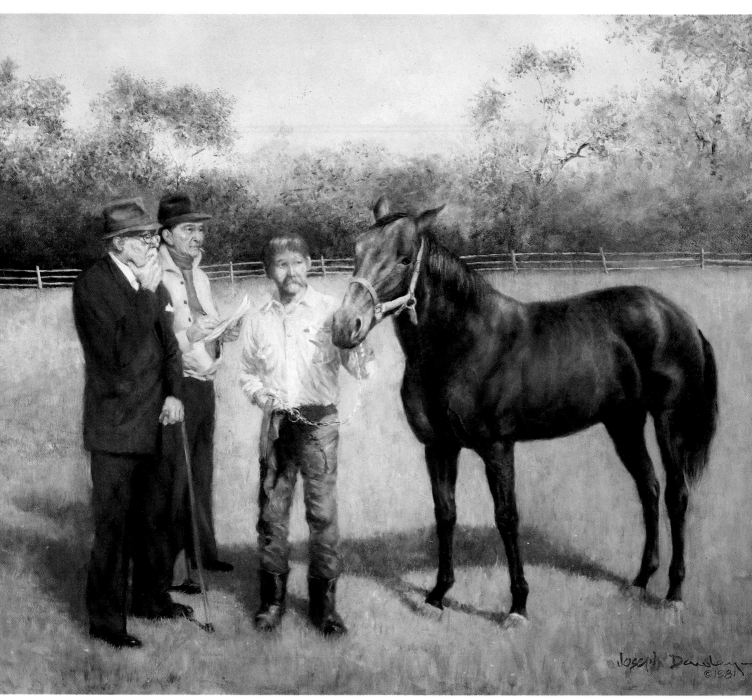

PURCHASING A HORSE, oil on Masonite, 20″ x 24″ (50.8 cm x 61.0 cm)

Assembling a Composition from Several Photos

Some of my paintings are done from one or two photographs; others pull together elements from a number of photos—I may use as many as nine in a single painting. Obviously, the more sources I use, the more complex the task of drawing them together; I have to take into consideration such variables as placement, proportions, light, and color, all of which may vary from one photo to the next.

I saw this man cracking coconuts on the dock in St. Thomas and thought the scene would make an excellent painting. Unfortunately, the men didn't like being photographed. I couldn't get very close without being threatened, so I just had to shoot at random and piece the composition together later on.

I used the coconuts and boxes from photos A and B, changing the boxes to solid wooden crates. The man in the straw hat is from photo A; the man with the machete from photo B; the seated man from photo C; and the woman on the right from photo D. The man in the red beret was very menacing, and I didn't dare take his picture. I remembered what he looked like and sketched him when I got back to my hotel.

I wanted to portray the openness and beauty of the harbor, so I removed the boat that blocked the view and painted a variety of boats and landscape elements from my imagination and photos C and D. I made up the empty coconut shell in the lower left corner; it is there strictly for balance.

The strong tropical light really ties this scene together. Note how I changed the light on the figures, particularly the seated man and the man in the straw hat, to give the impression of harsh sunlight. This is carried through in the coconut and crate in the foreground and in the sharp light-and-shadow pattern in the pile of coconuts. I also made some adjustments so the light would be hitting all the figures from the same direction.

The blue shirts of the men on either side of the canvas and the repeated verticals in the background also help tie this composition together.

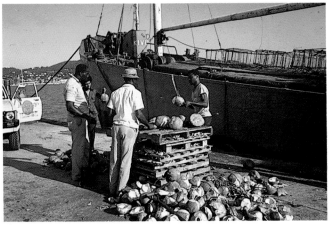

A

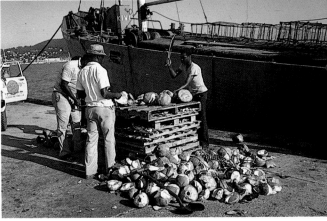

B

C

D

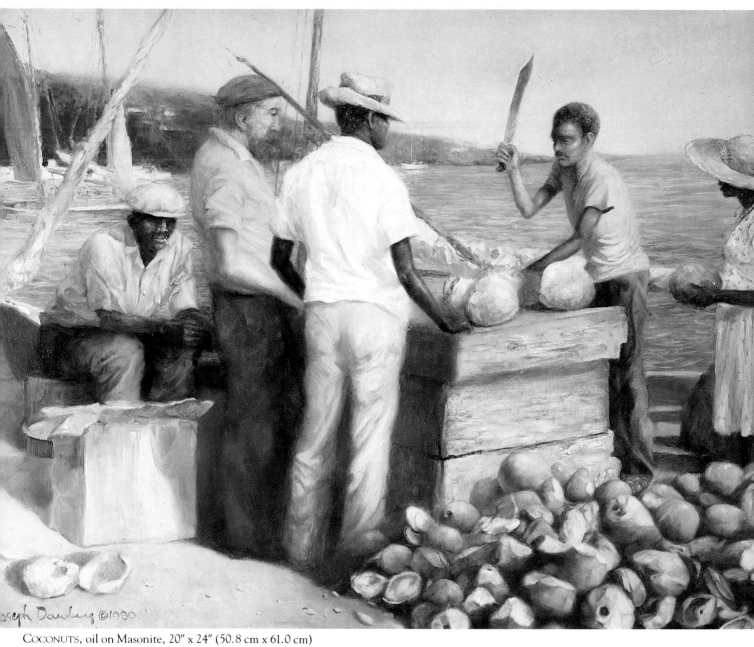

COCONUTS, oil on Masonite, 20″ x 24″ (50.8 cm x 61.0 cm)

Color and Contrast Strengthen a Composition

This is another St. Thomas scene pieced together from several photographs. As you can see, these photos have no real charm of their own; for the most part, they just give me ideas and clues that I can develop into interesting paintings.

Much of this scene comes from photo A; I liked the figures, the coconuts at their feet, and the pink building in the background. I did change the appearance of the truck, because I didn't think a meticulous rendering of its details would add much to the scene. It does serve a structural and compositional purpose, though, so I left it as an indistinct shape—it looks like a shallow open container. The man standing on the right is from photo B; I moved his arms so he would be holding the coconut. The background came from other photos.

The light in this painting is very strong, and areas of high contrast are important to the composition. In the upper half of the painting, the shoreline aligns with and emphasizes the horizontal sequence of dark faces against light backgrounds. The lower half of the painting is dominated by a set of dark vertical shapes: the legs of the man on the left; the shadowed side of the crate; the legs of the man overlapped by the truck; and the bed of the truck itself, partly divided by the figure standing in front of it.

I made the colors more intense than those in the photos, to make the painting more pleasing and to strengthen the composition further. The most important change was intensifying the pink of the building on the left; the eye is attracted there and then is led horizontally across the canvas by the sequences of light and dark shapes. The pink sail on the right echoes the color of the building, just as the coconuts in the foreground echo the green of the mountain in the background. These repeated colors help unify the painting and keep the eye moving; other surprisingly colorful areas are the crates on the left, the opened coconuts at the feet of the foreground figure, and the shirt of the man in the center.

A

B

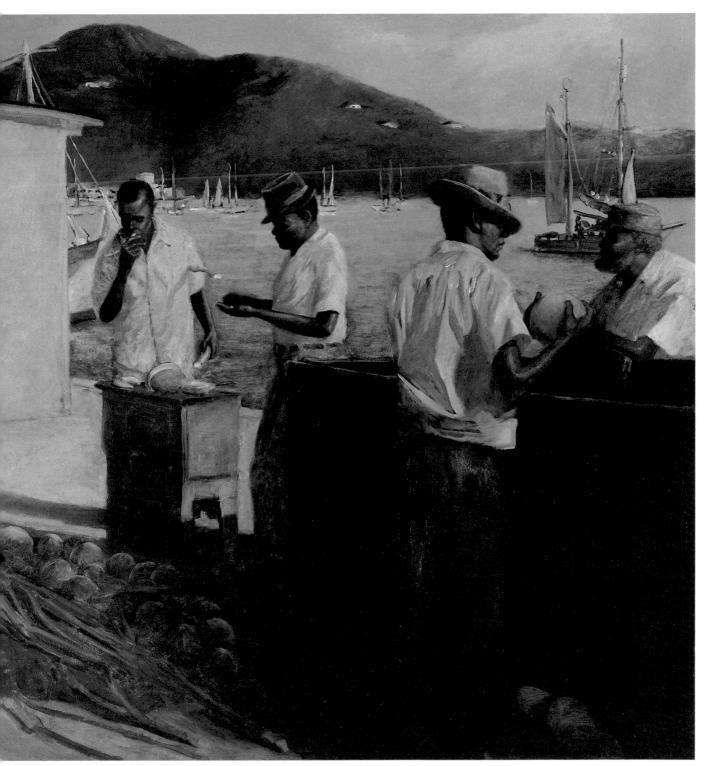

CHARLOTTE AMALIE, oil on canvas, 30″ x 40″ (76.2 cm x 101.6 cm)

Color and Composition in an Improvised Landscape

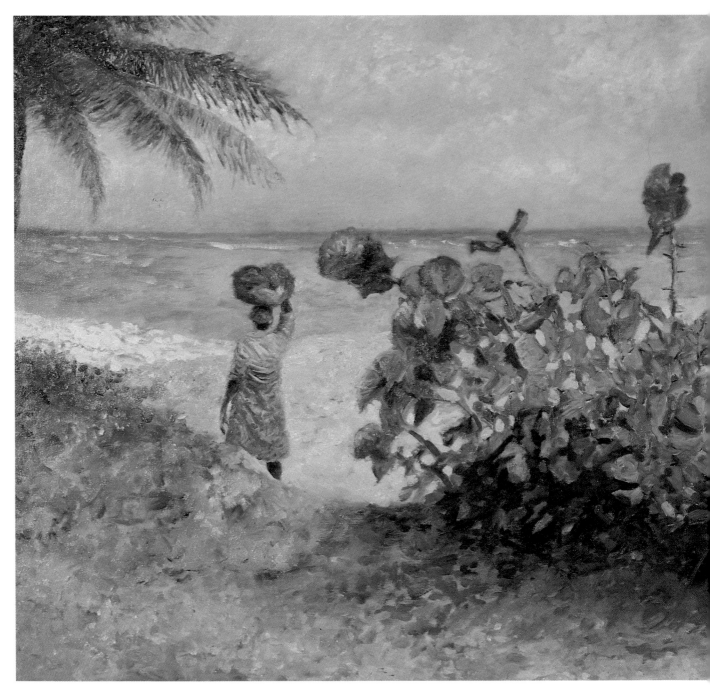

SEA GRAPES AT JAMAICA, oil on canvas, 24″ x 30″ (61.0 cm x 76.2 cm)

I got the idea for this painting on a trip to Jamaica. I wanted to capture the natural beauty of the land, and I thought the image of a lone woman on a tropical beach would be perfect. Once again, I assembled the image from several photographs.

The setting is from photo A. I removed the light post and the sidewalk in the foreground, replacing the latter with sand, so the scene would appear more natural. I also brightened the colors overall and changed the light to suggest the strong tropical sunshine.

The woman is from photo B. She is a little to the left of center and is wearing a pink skirt and white blouse. The box she was carrying didn't quite embody the native charm I was looking for, so I changed it to a basket. I also darkened her shirt and changed the pink of her skirt to a deeper red so her figure wouldn't blend in too much with the surroundings.

The palm fronds in the upper left corner of photo A just didn't work in the painting—they looked droopy and sick. I needed something in that corner to balance the composition, however, so I used the fronds from the much healthier tree in photo C.

A

B

C

Color and Composition in an Improvised Landscape

The predominant color in the sea grapes is permanent green, mixed with yellow ochre in places to depict the sunlight coming through the leaves. I placed touches of pure cadmium orange here and there. The purple tone in the shadow area is ultramarine violet.

There are four different blues in the sky: ultramarine blue, phthalo blue, cerulean blue, and cobalt blue. All are mixed with white. Some permanent mauve is blended into the blue in places to provide variety and depth.

I used ultramarine blue and phthalo blue for the water. They are mixed together in some areas, particularly at the horizon, where the sea is darkest. I also used a little permanent mauve in some areas. The waves were modeled with titanium white mixed with a little cerulean blue.

The basic color is cadmium orange mixed with a lot of titanium white to raise the value and lower the intensity. I brushed this into the entire sand area first, then went over it with small strokes of ultramarine violet, cadmium yellow, and other colors.

Placing Figures in a Landscape

The space is broader and deeper in this painting than in the previous one, and there is a more pronounced feeling of movement, largely because all the figures are in motion.

As you can see, the photographs I worked from are all very similar—they are all of the same Jamaican beach and the perspective is the same. While individual figures and objects are taken from the various slides, the setting of the painting is a composite of all four. I was trying to

capture the general sense of the scene, rather than any particular location or moment. The water and the wet sand, for instance, aren't from any one photo; I showed the water ebbing and flowing as I pleased, adjusting it a bit so it would work with the overall design. I also made up most of the trees, just using the photos as a general reference.

The two girls are from photo A. I wanted to differentiate the two, so I moved the younger child to the left. I have caught her in mid-stride; the

swing of her dress to one side adds to the sense of motion. The other figure is a grown woman in the photo, but I slimmed her down because I was looking for the lithe movement of a teenage girl. I changed some details of both girls' clothing and hair; the young girl's dress and the older girl's blouse and bandanna are all different reds, but I kept the white yoke of the younger girl's dress for definition. The older girl is carrying a fish and a pail in the photograph; I changed them to a

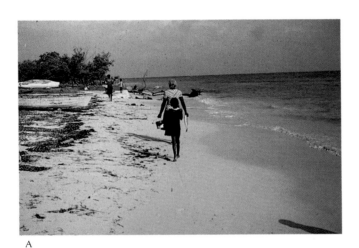

A

B

C

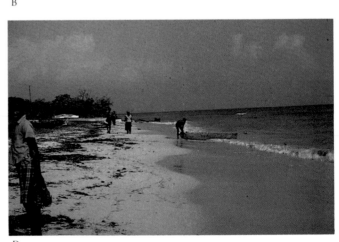

D

basket in the painting, altering the shadows accordingly.

The same fisherman and boat appear in photos C and D; I used both photos without major changes to create an image of two fishermen and two boats. Again, the figures are caught in the act of doing something; their positions indicate movement.

Photo B was my main reference for the driftwood. I strengthened the flowing limbs and eliminated the debris around them.

I used ultramarine blue for the sky, with some phthalo blue in places. I wanted touches of pink, so I brought in some permanent mauve and cadmium red mixed with white. These colors are echoed in the sea.

The basic color of the sand is yellow ochre and white. Where it is wet, I used a raw sienna tint to darken it. The waves lapping the beach are yellow ochre, phthalo blue, cadmium orange, and white.

When all this was painted in, I took a long, hard look and realized that the composition wasn't right. The beach was just a large expanse of clean sand, very consistent, with nothing to break it up or add interest. I added the seaweed, which I had left out because it seemed dirty and unappealing; be that as it may, it added a great deal to the painting. I also added the three people walking in the background. The woman in the middle is from photo C; the other two are made up. They helped resolve the painting and added to the sense of movement.

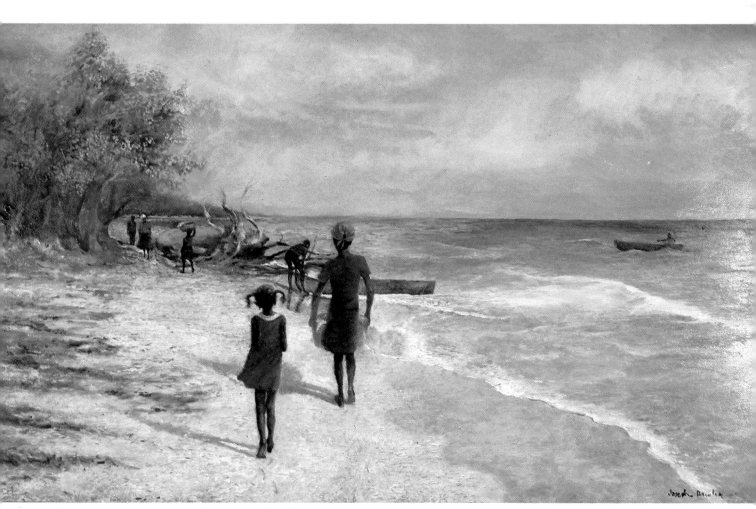

BOATS COMING IN—JAMAICA, oil on Masonite, 24″ x 48″ (61.0 cm x 121.9 cm)

Establishing a Strong Focal Point

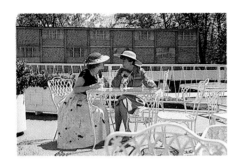

One of my goals in many of my impressionist paintings is to mimic the way the eye sees. This is primarily a question of focus: In general, objects in the center of the field of vision appear sharp and well-defined and objects in the periphery are less distinct. I achieve this effect in my paintings by having a clearly defined focal point in the middle ground, usually in the center of the canvas, and rendering objects less distinctly as they move toward the edges or into the foreground or background. The farther a color is from the focal point, the less intense it will be.

The focal point of the next three

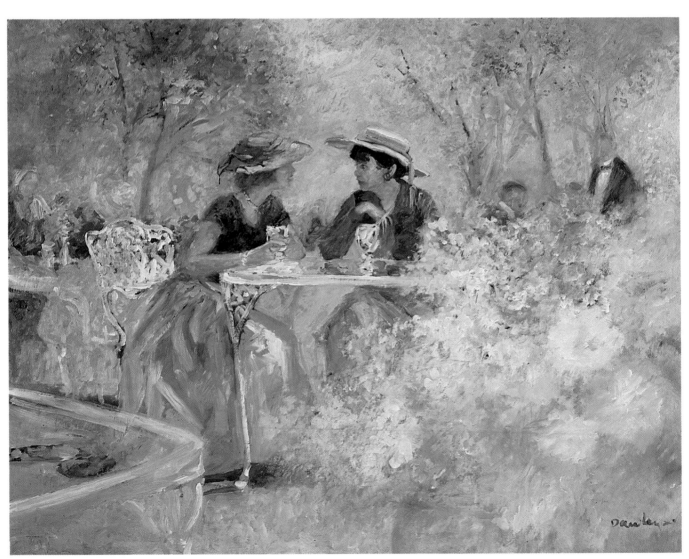

MONIQUE'S, oil on canvas, 24″ x 30″ (61.0 cm x 76.2 cm)

paintings is the two women in the center; they are also the only characters that come from the photograph. I basically made up all the other figures and details.

In *Monique's,* I placed a bouquet of flowers and the corner of a table in the foreground to anchor the painting; both are close to the view- er and out of focus. The trees in the background are rendered in a hazy manner that makes them seem very distant; the brownish purple of their trunks seemed to fit in well with the colors in the rest of the picture.

The two women in *The Eavesdrop- per* are joined by the waitress, who is listening in on their conversation. Because she is part of the center of interest, she is painted more clearly than the other background figures. The sharper focus brings her forward.

The colors of this painting are darker and less pretty than those of the first one; the eavesdropper has added a sinister note to this scene.

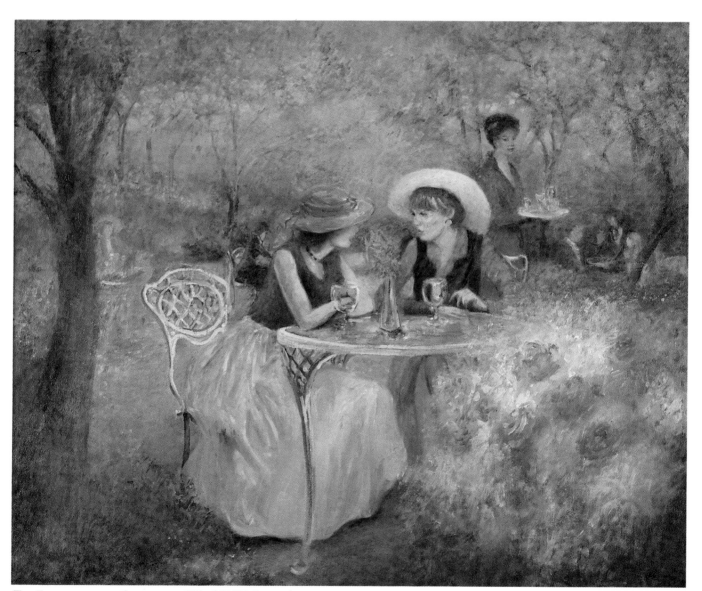

THE EAVESDROPPER, oil on canvas, 30″ x 36″ (76.2 cm x 91.4 cm)

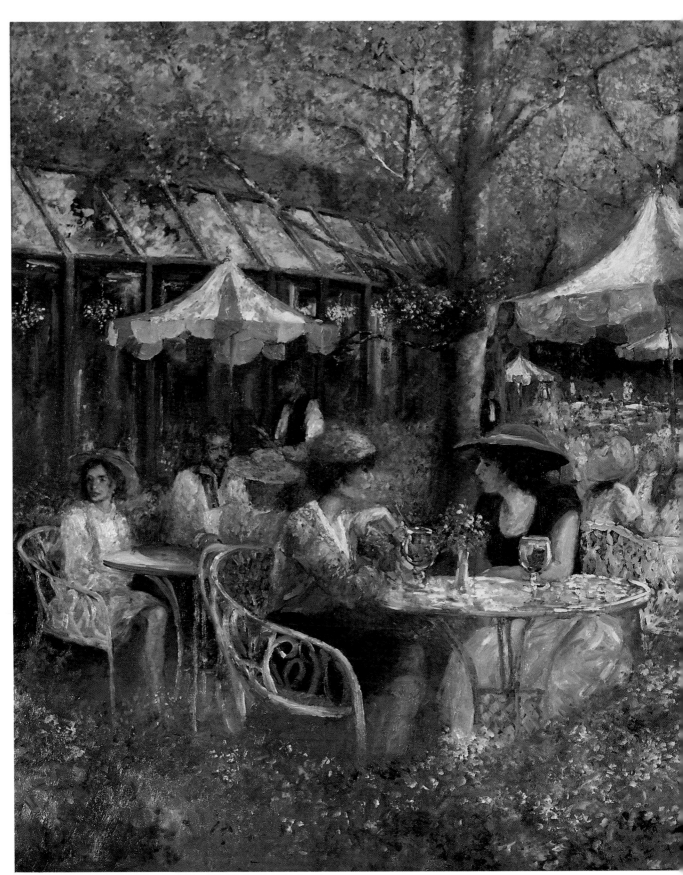

IDLE CHATTER, oil on Masonite, 36″ x 57″ (91.4 cm x 144.8 cm)

This is the most complex and the most interesting of the three paintings; this scene has more depth and detail, brighter colors, and stronger contrasts than the other two.

I reversed the positions of the two women here because I wanted the red hat to be closer to the center of the painting. This balances the color a little better. I changed the left-hand woman's white hat to blue and added a blue-gray vest over her red blouse to provide stronger contrast with the reds in the painting and to echo the cooler colors of the scene.

The clarity of the various elements diminishes in proportion to their distance from the focal point, but the change in focus is more gradual than in the previous two paintings because of the deeper space. In this painting, the two women do not stand out as much but are integrated better into the overall scene.

Anchoring the Foreground

The basics of this painting were fine, but they just didn't come together into a pleasing composition. I liked the positions of the women in photo A; because it was so overexposed, I used a similar photo for the details, such as the folds in their clothing. The courts and trees were from photo B. When I had all these elements painted in, I realized the painting was too bland and the composition didn't look right.

My solution was to anchor both ends of the terrace by placing the pink flowering plant and the green shrub in the foreground. For the sake of color balance, I echoed the pink in the wall on the right and the pink flowers behind that.

The pink mass in the foreground is out of focus because it is so far forward; the brushstrokes are large relative to those in the rest of the painting. The color is made up of touches of permanent mauve, cadmium red medium mixed with white, and a little rose madder mixed with white. Some of the blue-green background shows through the brushstrokes.

For the skin tones, I used yellow ochre with a little cadmium red medium. I varied the amount of white in the mixture according to where the light fell. The shadows are ultramarine blue mixed with raw sienna. Usually pink does not work well with skin tones, but I had enough contrast here to pull it off.

There are a number of greens in the trees. I used yellow ochre and sap green for the mass of trees to the left, adding a little raw sienna where the color shifted toward brown. The predominant colors in the right-hand group of trees are chromium oxide green and yellow ochre; where the tree gets browner, I brought in sap green with the touches of ultramarine violet and cadmium red. My technique in these background trees was to use blending and some short strokes. The blue spruce in the center is viridian and white; although viridian is a bluish green, I added some ultramarine blue as well. The tree has more definition than the others—the lights are lighter and the darks are darker.

The tennis court is phthalo green and white, with a few touches of other colors.

A

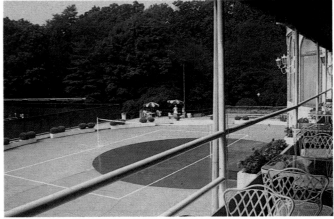

B

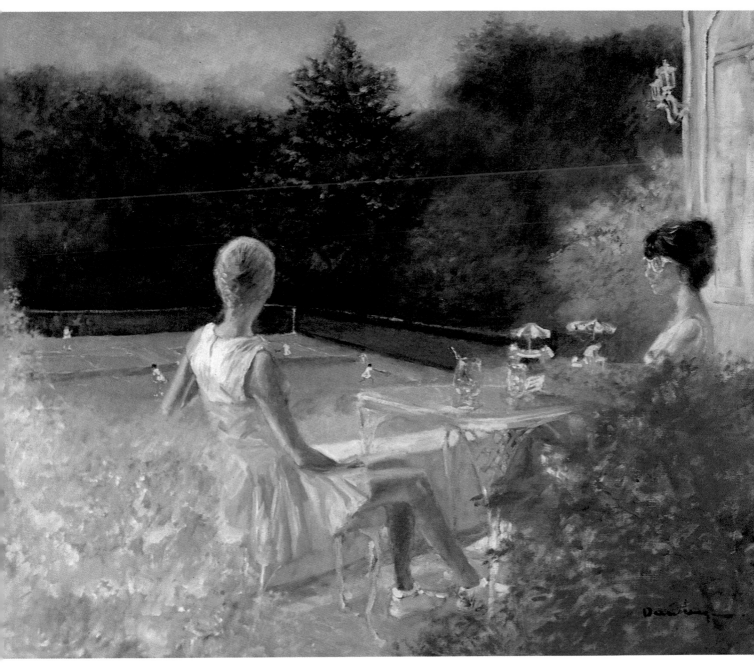

AT THE TENNIS CLUB, oil on canvas, 24″ x 30″ (61.0 cm x 76.2 cm)

Balancing a Composition with Two Figures

My original design for this painting was to have one boy leaning over and the other sitting down. I did some preliminary sketches to try out possible arrangements; in the sketch here, I took the seated boy from photo A and the other from photo C. There was something unsettling about the standing boy, so I decided to use two seated figures. I felt this would add to the serenity of the scene.

I liked the boy sitting on the rock in photo A, so I used that figure; the other boy came from photo B. The angle of the bank and the view of the river in photo C were pleasing, so I used them, adding the sailboat and dog from photo D. The latter was an afterthought to anchor the design of the painting and add human interest.

I brushed in these major components and then started painting. I didn't like the near boy's striped shirt, so I changed it to plain white; I left the other boy's shirt red with just a hint of stripes.

I brought the far bank into the picture more by lowering it and adding trees, underbrush, azaleas, and touches of sky peeking through. All this added visual interest and made it seem more real. I tied it into the foreground with the leaves in the upper right-hand area, which are from a bush on the near bank.

I added a lot of blue to the water, then brought in the reflections from the far bank. I also added slight circular ripples around the near sailboat to show its movement. At this point, I felt the painting was complete and I set it aside.

A

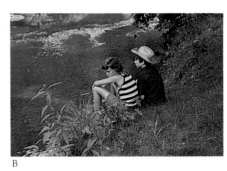
B

C

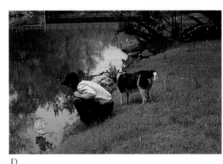
D

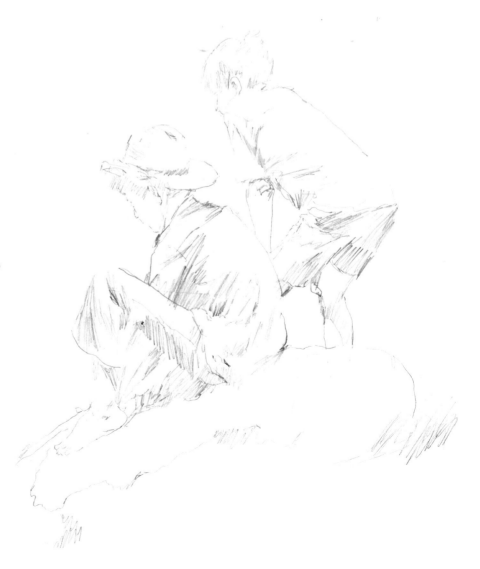

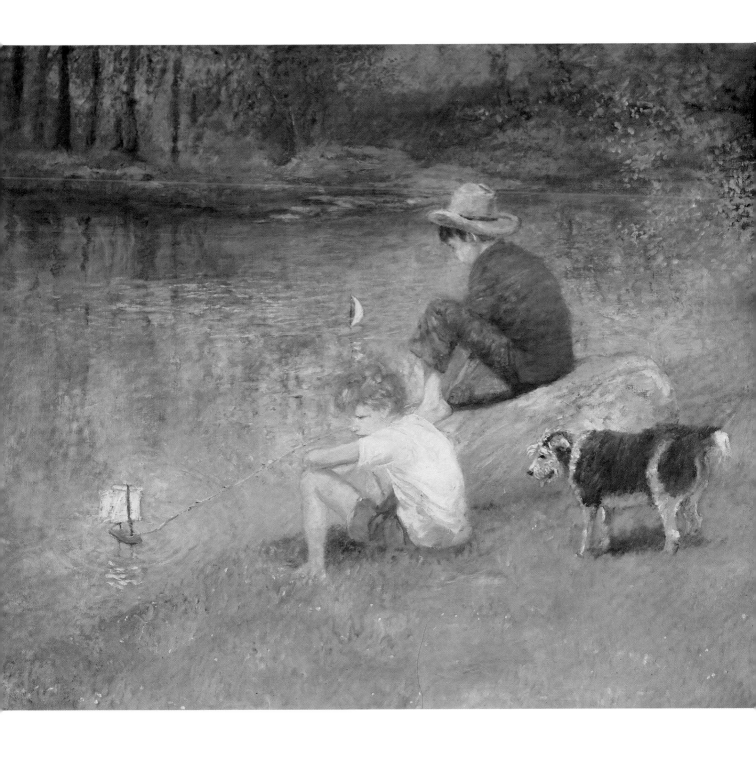

Balancing a Composition with Two Figures

After some time had passed, I looked again and didn't like what I saw. The painting seemed too commercial—the colors were too cutesy, like those of a color snapshot. Another problem was that I had combined traditional and impressionistic painting. Actually, that is true of the final version as well, but at this stage the touches of impressionistic fantasy evoked by color were noticeably lacking.

I changed the colors of the boys' shirts and deepened and strengthened the skin tones of the boy in the foreground. I also darkened his hair.

The boy on the rock presented a problem: When I darkened his shirt, it blended with his jeans into an undefined blob. I solved this by moving his arm to this side, with his hand resting on the rock. This clarified the form of his torso.

The grass had been too bright a green; I added a lot of color, defining tones and sprinkling touches of wildflowers here and there.

The entire background needed to be toned down, so I darkened everything there and glazed over the pink azaleas, allowing just a hint of color to show through. This set off

the boy on the rock much more clearly; to increase the effect, I darkened the reflections and the leaves on the right. I also darkened his straw hat a bit. Then I stood back and took a long, hard look at the whole painting.

This scene just needed a few finishing touches now. I changed the color of the foreground boy's shorts, lightened the straw hat again, and softened the colors of the dog. I brought in some shadows, faint on the grass, stronger on the rock. Finally, I added a little more blue to the water.

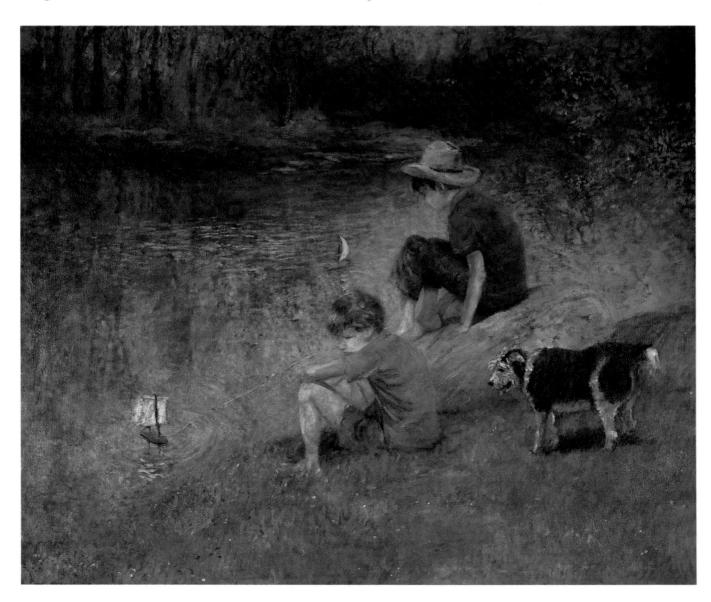

Two Boys by the River, oil on canvas, 30″ x 36″ (76.2 cm x 91.4 cm)

Composing a Group of Figures

Whenever I run into problems with a painting, I change things around—the composition, the colors, the details—to try to make it work. Usually I am successful, but sometimes even my best efforts fail. In that case, I set aside the failed painting and start afresh. I have learned a great deal from my mistakes.

My first attempt at painting this scene was the large canvas shown here. The subject just wasn't coming together. I'm not sure why; it may have been that the size of the figures exaggerated the perspective, or that the background was too busy. At any rate, I finally decided that reworking this painting was too massive an undertaking and resolved to start over on a smaller canvas.

Before I launched into the next version, I did a series of compositional sketches to get an idea of how the figures looked in different arrangements.

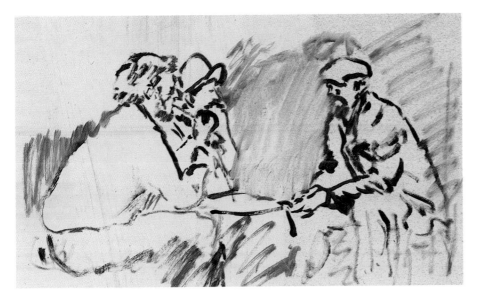

In this sketch, I didn't change the man on the left, except for removing his glasses. I gave the man in the middle a hat with a more dramatic brim, and I added a beard and moustache to the man on the right.

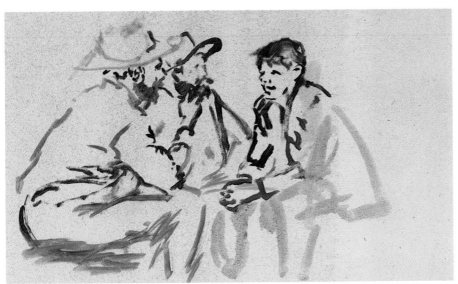

Here, I moved all the figures closer together for a tighter group. I gave the man on the left a wide-brimmed hat and altered the hat and arm of the center figure. The man on the right changed the most: I removed his cap, moustache, and beard.

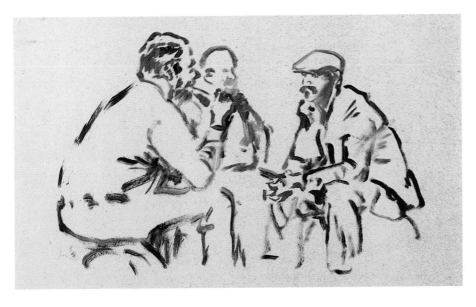

In the final sketch, I moved the men farther apart again and removed the hats from the two men on the left.

Composing a Group of Figures

Now I picked up the small canvas and tried again. This time, things did work out, thanks in part to the sketches I did in advance. I used the basic arrangement of the first sketch. To keep the man in the center from looking too hunched over and confined, I raised his arm, as I had in the second sketch.

I changed the features of all three men and eliminated the cast shadows that obscured their faces in the photograph. The predominant colors in the skin are cadmium red medium, yellow ochre, and white. I also used a mixture of cadmium red light and yellow ochre here and there and, in the shadows, ultramarine blue mixed with yellow ochre. All this was applied in broken-color fashion, the brushstrokes of different colors side by side, for maximum richness and saturation.

I handled the clothing as simply as possible, using solid colors rather than patterns to keep the area from looking too busy.

I was tempted to paint the little houses in the background, but I remembered my problems with the first painting, where the expansive scene detracted from the three main characters. Instead, I isolated the men with only trees and sky behind them; this provided depth without confusion.

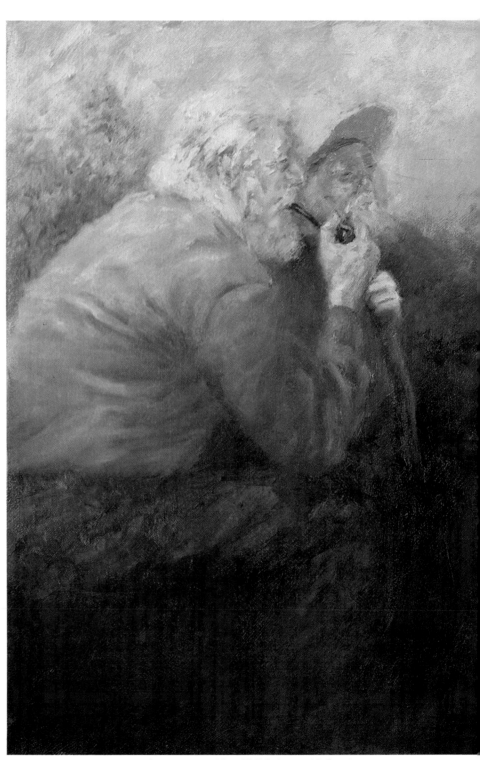

Fritz, Virgil, and Max, oil on canvas, 10″ x 12″ (25.4 cm x 30.5 cm)

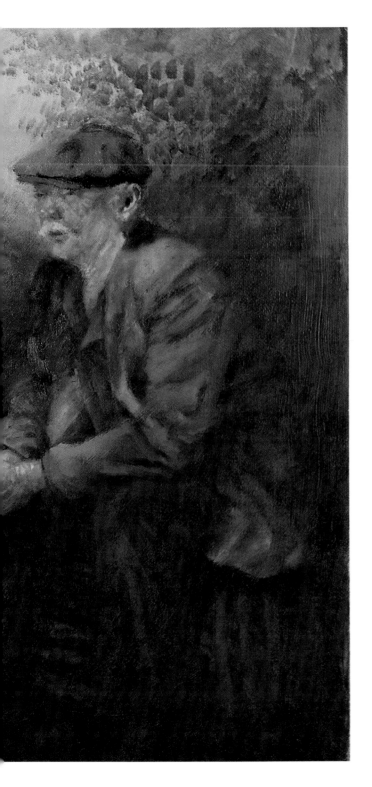

I used broken color for the skin tones: individual touches of cadmium red medium, yellow ochre, cadmium red light mixed with yellow ochre, ultramarine blue mixed with yellow ochre, and white.

Resolving a Compositional Problem

I liked this scene so much that I didn't realize until the painting was almost finished that I had made a serious compositional error.

I used a single photograph and didn't change it much. My palette was light and airy, with a lot of pastels. Note the yellow sunlight and blue-purple shadow on the road, the touches of rose in the sky at left, the difference in color and value between the trees and grass in the foreground and those in the distance. I cropped out the lower part of the photo and thinned out the crowd a bit. The women and children near the center of the painting were an important element; I added more color to their clothing to make them stand out more. I felt the painting was complete and was very happy with it.

Then someone pointed out that the pole near the center of the painting appeared to be emerging from the girl's head. This is an embarrassing oversight indeed; fortunately, I had used thin paint for the pole, so I painted over it without any problem. This seemed to throw off the composition a bit, so I added more foliage at right to balance it.

The moral of this story is that you should always check your composition carefully—a basic design flaw could ruin your painting.

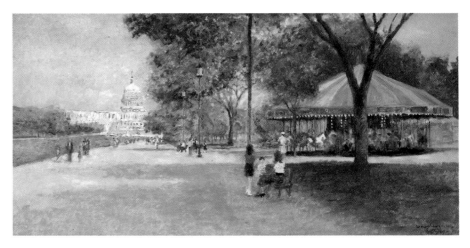

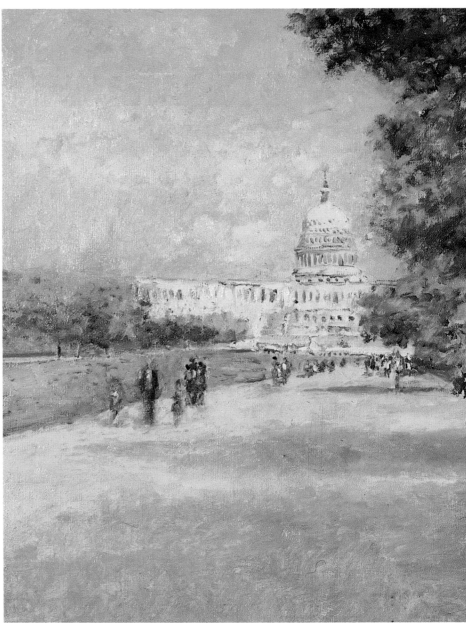

CAROUSEL AT SMITHSONIAN, oil on canvas, 20″ x 36″ (50.8 cm x 91.4 cm)

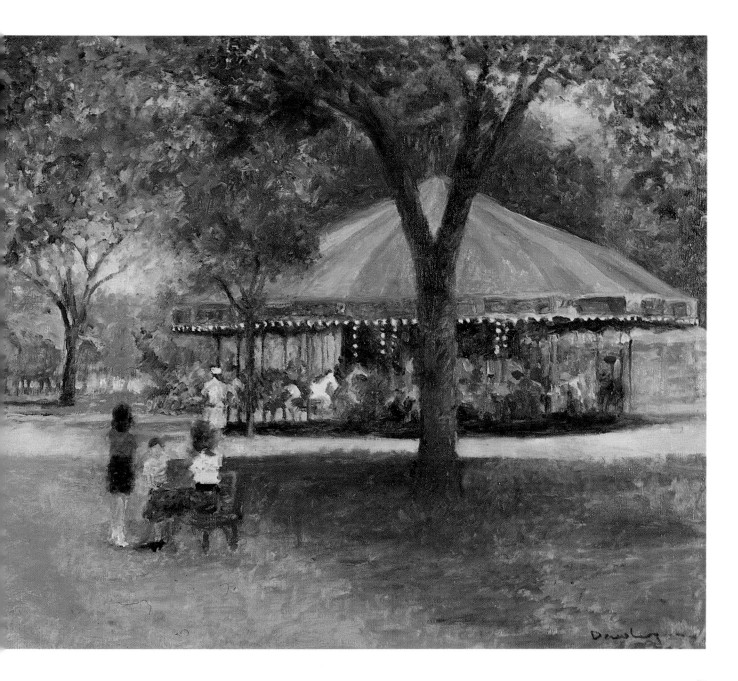

Simplifying a Cluttered Scene

I liked the dock and everything behind it in this photograph, but there was too much clutter. I did some quick compositional sketches to see how to resolve this problem.

I started out sketching the scene pretty much as it was in the photo, devoting most of my attention to the boats and water. I needed to see how the boats in the foreground would influence my composition and use of detail.

I didn't like the foreground boats, so I eliminated them in the next sketch and enlarged the grassy knoll. Trying a different tack, I added a boat tied to the end of the dock and some others alongside the pilings. I knew I wanted a couple of seagulls in the final painting, so I added them here. I also brought in a little more color than in the previous sketch, using the same blue for the sky and the water.

The boat tied to the dock seemed too large in the last sketch, so I made it smaller and colored it red. I eliminated it altogether in the final painting because it just didn't seem to work. I elaborated the lobster pots on the dock a little more here, and I tried a brighter color for the water.

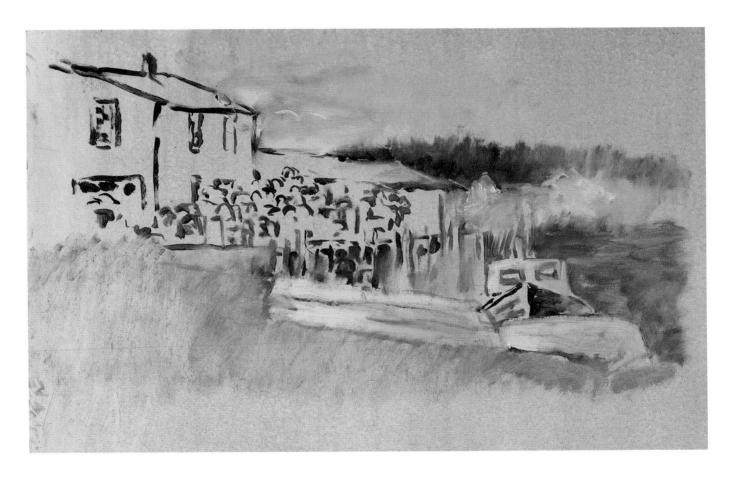

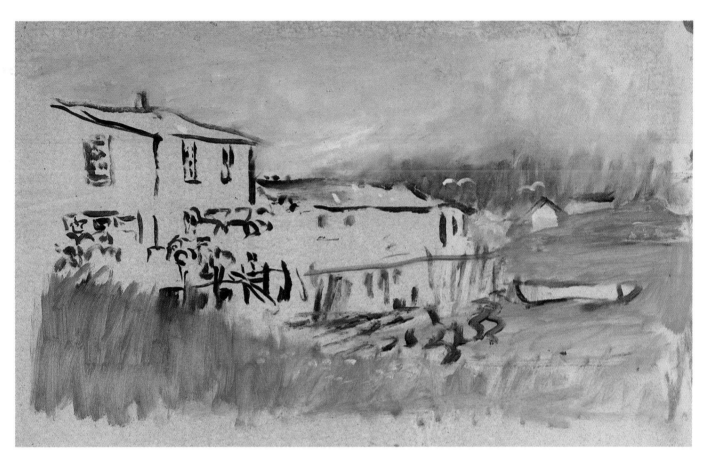

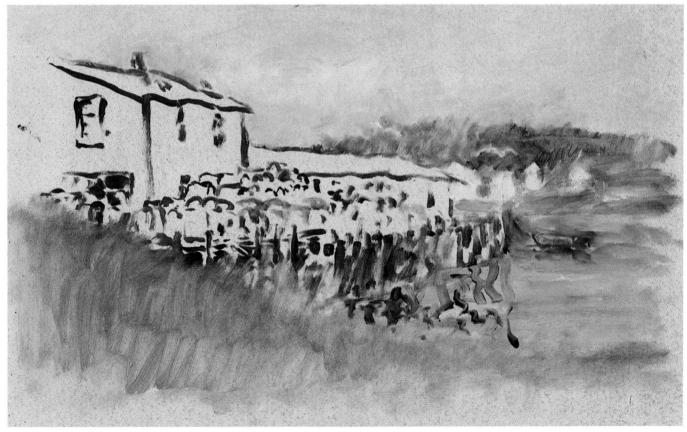

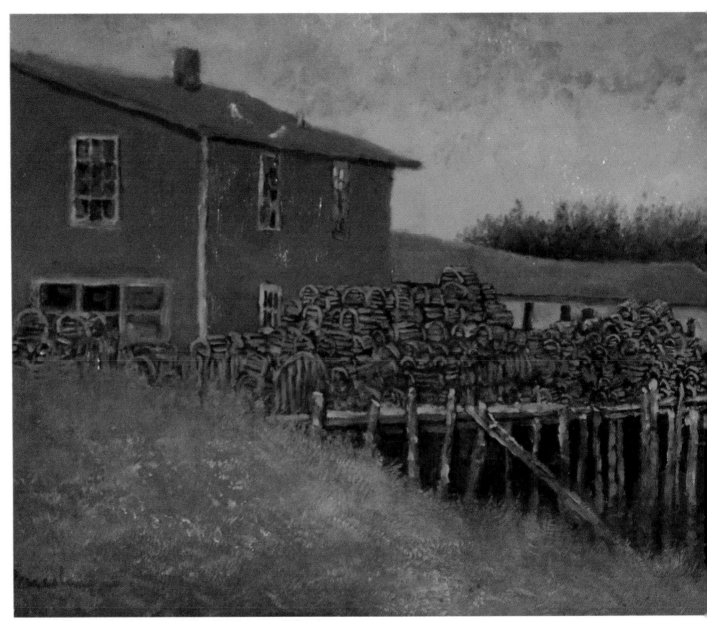

LOBSTER DOCK, oil on Masonite, 10″ x 18″ (25.4 cm x 45.7 cm)

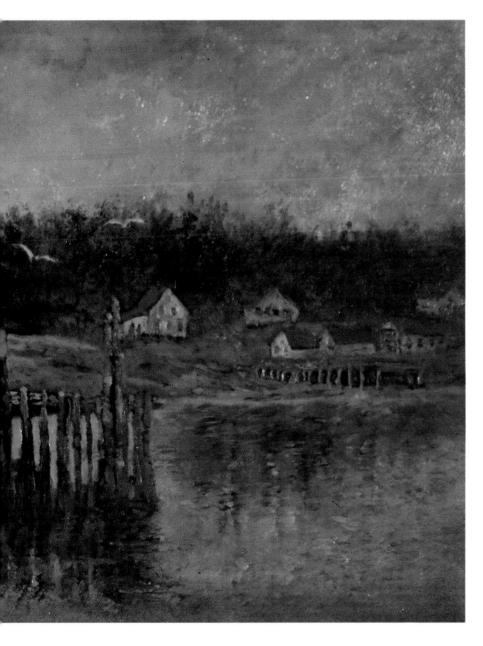

Thanks to the preliminary sketches, the composition of this painting is clear and uncluttered. The grassy knoll looms large in the foreground, but the focus is soft and color changes are minimal, so it doesn't attract undue attention. I rearranged the lobster traps a bit and changed the color of the building beyond to a brownish green that seemed to harmonize with them. I changed the pilings by eliminating the ladder and one climbing post, leaving only one access to the pier.

The trees in the background presented a good dark backdrop for the seagulls, so I eliminated a few of the houses. I used blue with touches of purple for the sky and repeated those colors in the reflections on the water.

The Evolving Composition

I didn't plan this painting out in advance; I just selected a subject that I liked and started sketching it out on canvas. As I worked, I was continually making changes and adjustments; this is a hit-or-miss method of painting, but the results can be very satisfying.

The stimulus for this painting was a photograph I took on a drive through a local park.

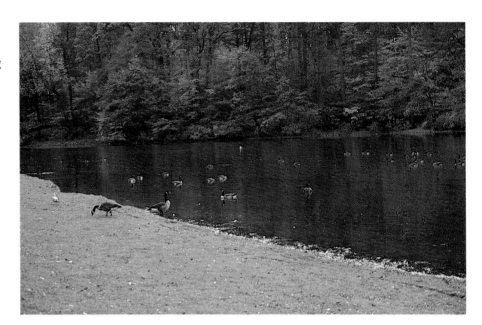

I liked the diagonal shoreline in the foreground with one goose feeding on it and another nearby, so I drew that in first. Then I loosely brushed in the rest of the scene to establish the mood. At this point, the diagonal was the most important element of the composition.

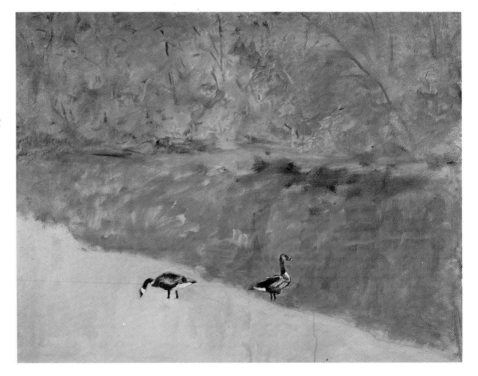

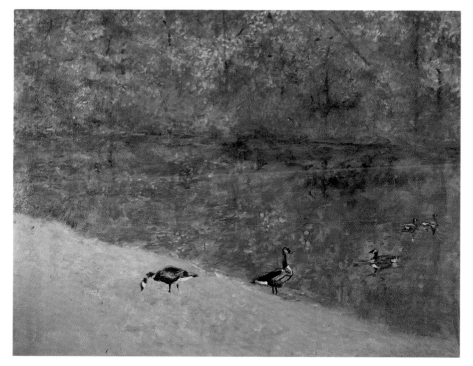

Now I started bringing in more color and detail. I added three more geese from the photograph. Since this is a fall scene, I used warm colors for the trees in the background—oranges, yellows, reds, and a few touches of green. I used a lot of broken color in this area. As I began brushing in the grass in the foreground, I realized that there was too broad a sweep of green; this area would need to be cut back.

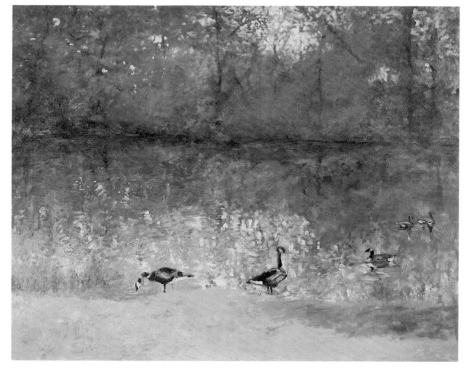

The strong diagonal has been eliminated and the bank is now horizontal; the shadow in the lower right corner is the only vestige of the original shape. I brought the geese to the water's edge. The new composition is based on three horizontal bands—the trees, the water, and the foreground grass.

I liked the idea of the sky contrasting with the background and being reflected in the water, so I cut back the trees a bit to let the sky show through. This really opens up the background and brightens the whole painting. I scrubbed over some of the background foliage with a thin layer of white, or in some places white mixed with Naples yellow or yellow ochre. This reduces the contrast and color intensity of the area but lets the colors show through; it pushes the trees back into the distance and produces a lovely veiled effect.

The Evolving Composition

The composition seemed too simple; it needed a large, heavy form to break it up and add some vertical interest, so I added the tree in the foreground. Note how the brushstrokes define the form here—the curve of each stroke follows the curve of the tree trunk, resulting in a sense of roundness. I used purple and yellow in this area, with touches of red, blue, and brown for variety, but I kept the colors low-key because I didn't want the tree to overwhelm the foreground.

I used a lot of glazes at this stage — thin, transparent layers of cobalt yellow (aureolin), mixed with a lot of medium, on the trees, for instance. I covered over much of the exposed sky and reduced the high contrast in that area. For the first time, there is a clear color change where the trees end and their reflections in the water begin; the reflections are darker, greener, and vaguer.

I went over the foreground grass with sap green and cobalt yellow to make it darker and less intense. The painting has become darker and contrast has been lessened overall; one result of this is that the horizontal bands of the composition are less obvious. I did keep a little light blue in the water, where it meets the bank. This bit of reflection calls attention to the geese, who stand directly in front of it; I brightened their colors to make them stand out even more.

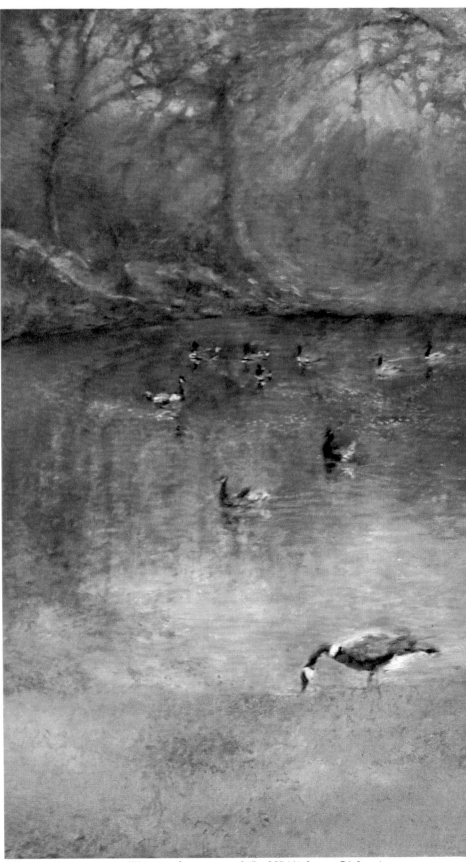

GEESE ON SHORE AND IN WATER, oil on canvas, 24″ x 30″ (61.0 cm x 76.2 cm)

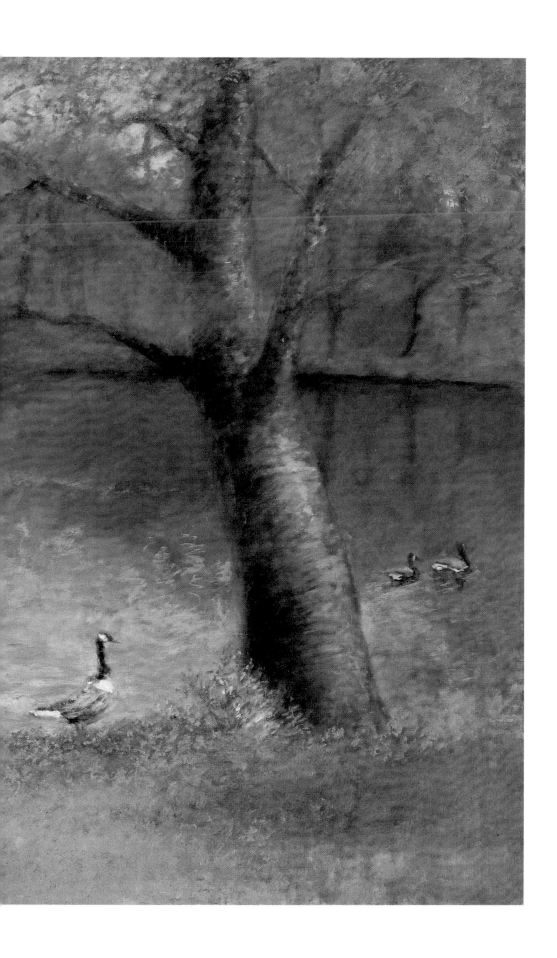

Adjusting Details to Refine the Composition

This scene looked like just what I wanted. The photograph was taken from my hotel window, so the quality is poor, but I liked the arrangement of the various elements.

I began by sketching in the subject on a white canvas with a mixture of ultramarine blue, yellow ochre, and white. Then I started laying in the colors. The painting consists of three major compositional elements: the trees, the sidewalk, and the street. This basic division worked well and once it was established, it didn't change; all my subsequent refinements had to do with details.

At this point, I was satisfied with the number and distribution of people in the scene. I had eliminated some distracting poles and street signs, and I had decided to eliminate all cars as well.

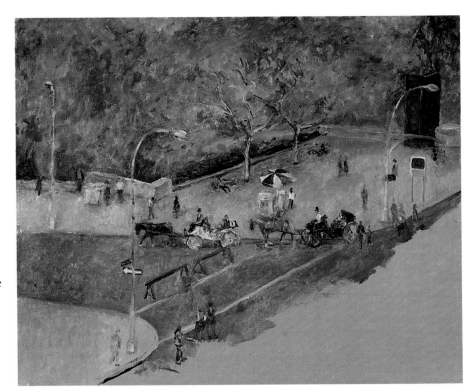

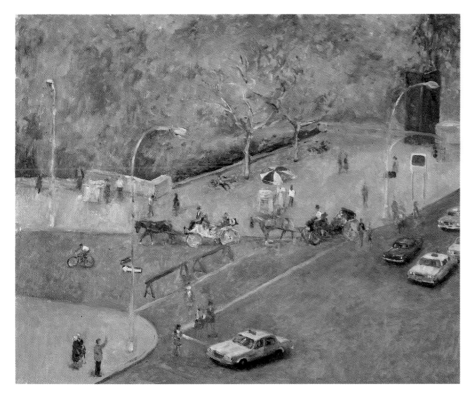

Everyone should have a trusted critic, preferably someone who is not an artist and therefore is more objective, to turn to for a second opinion. Mine is my wife, who has an excellent eye for design and color, and her opinion in this case was that I should add more people and some traffic to indicate that this is in a major city.

Accordingly, I added the bicyclist, the women on the near corner, and an assortment of cars. At this point, I felt that the design was correct and complete.

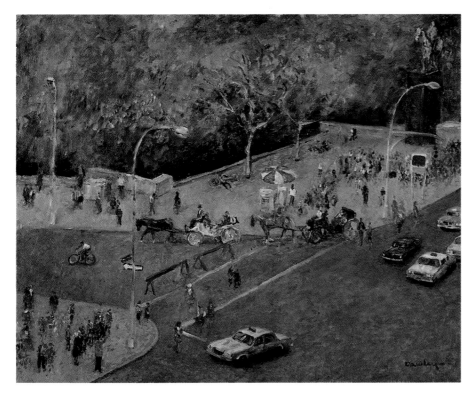

After studying the painting a while longer, I decided that more people were called for. I painted them in very loosely. At this point, I wasn't working from photographs anymore; I just made up the figures and positioned them in what seemed to be a pleasing arrangement. I also worked on the statue, defining its shape and adding color so it would stand out more.

I began modifying the color as well as the composition: The permanent green I had used for the trees seemed unnatural, so I went over them with mixtures of sap green, yellow ochre, and burnt sienna. This darkened them substantially. I also changed the colors of the vendor's umbrella so it would fit into the overall painting better.

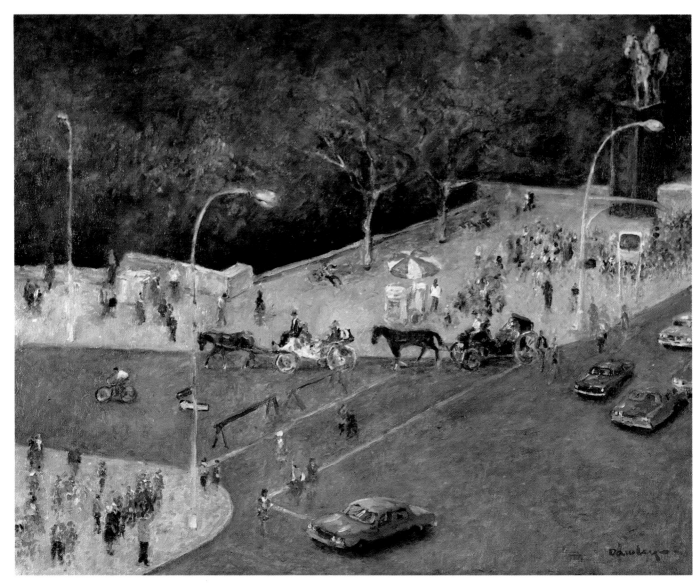

I still wasn't happy, so I called in the critic again. We decided that the color of the street wasn't right and that the cabs drew too much attention to the foreground. I changed their colors, then carefully brushed a simple gray made of black and white into the street. I added strokes of yellow ochre to the street and sidewalk to warm up the gray. I also continued working on the trees and the base of the statue.

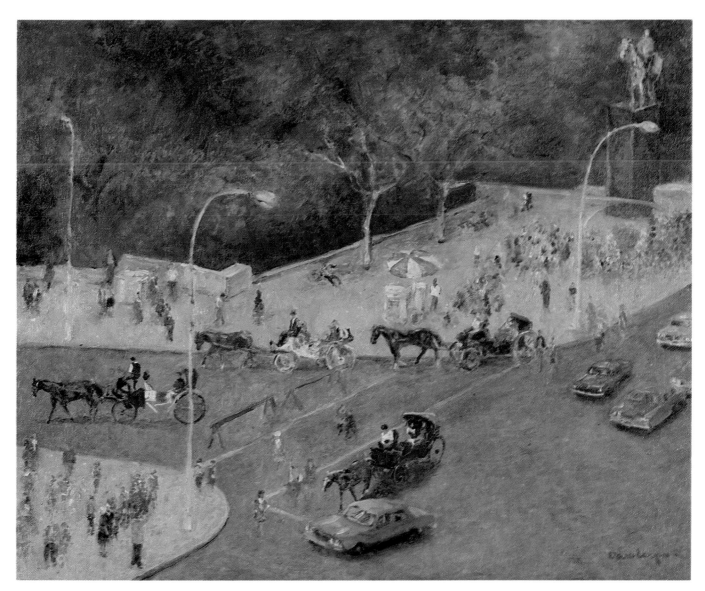

I wanted to make the painting more sophisticated, so some refinements were in order. I painted out several street signs that were too distracting. I decided the bicyclist wasn't adding to the romantic mood I was trying to portray, so I replaced him with a horse and carriage. I added another coach in the foreground as well.

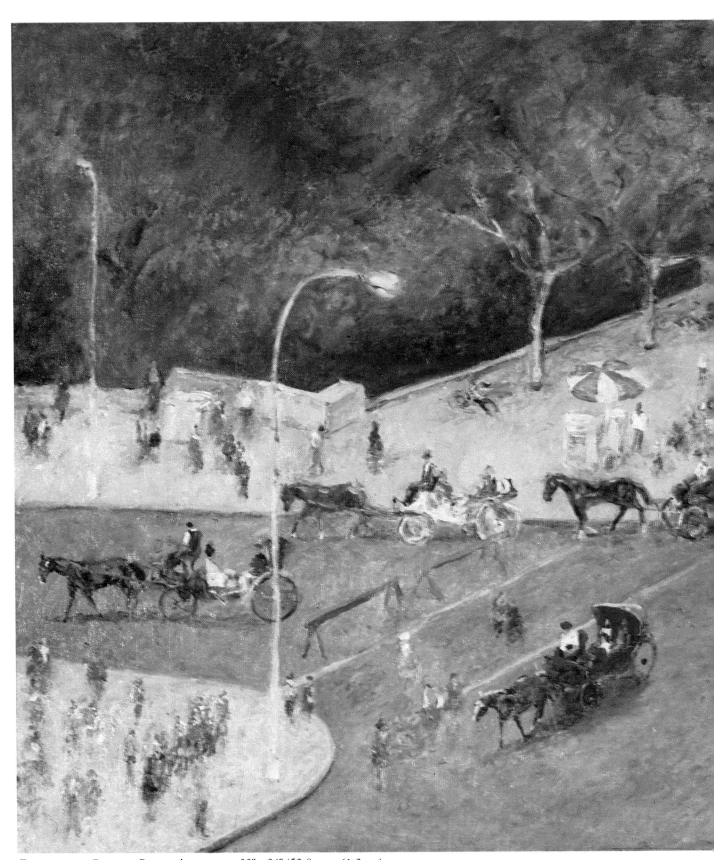

ENTRANCE OF CENTRAL PARK, oil on canvas, 20″ x 24″ (50.8 cm x 61.0 cm)

The key to establishing the romantic, nostalgic atmosphere, I decided, was to emphasize the carriages and shift the focus away from the more modern elements of the scene. I eliminated the blue car in the foreground, as it attracted far too much attention, and reworked the other cars so their forms were less distinct.

The man on the near corner bothered me because his gesture seemed cartoonish. I eliminated the gesture and repainted the other figures to make them blurrier.

At long last I am satisfied with the painting and consider it finished. The sequence is an excellent example of how it is often necessary to make a change, then step back and look at the whole painting to see what must be done next. It can be a long and painstaking process of going back and forth, making changes and undoing them, adjusting everything until it seems just right—but in the long run, it's well worth the effort.

Fine-tuning the Composition

This painting does not have a strong focal point; rather, points of minor interest are spread out throughout the canvas. Colors are light, pretty, pastel; values are closer together; there are no areas of strong contrast. The overall mood is calm and tranquil.

The major compositional problem I had with this piece was the positioning of the three main umbrellas. In order to resolve this, I did a few quick sketches to try out various arrangements.

I liked the tilt of the umbrella on the far right in the first sketch, but it overpowers, rather than enhances, the people seated beneath it and attracts too much attention to itself. I replaced it with an upright umbrella that fits in more gracefully.

To make sure this would work well with the other elements of the composition, I did a more complete sketch, adding the other umbrellas, the light pole, the trees, and the tables. I was happy with this last sketch, so I carried over these design elements into the final painting.

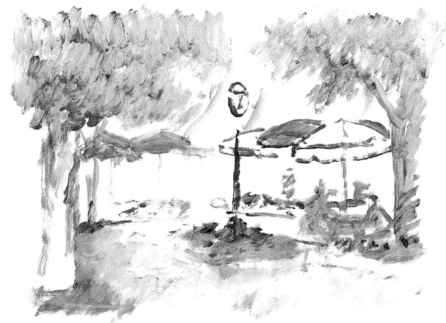

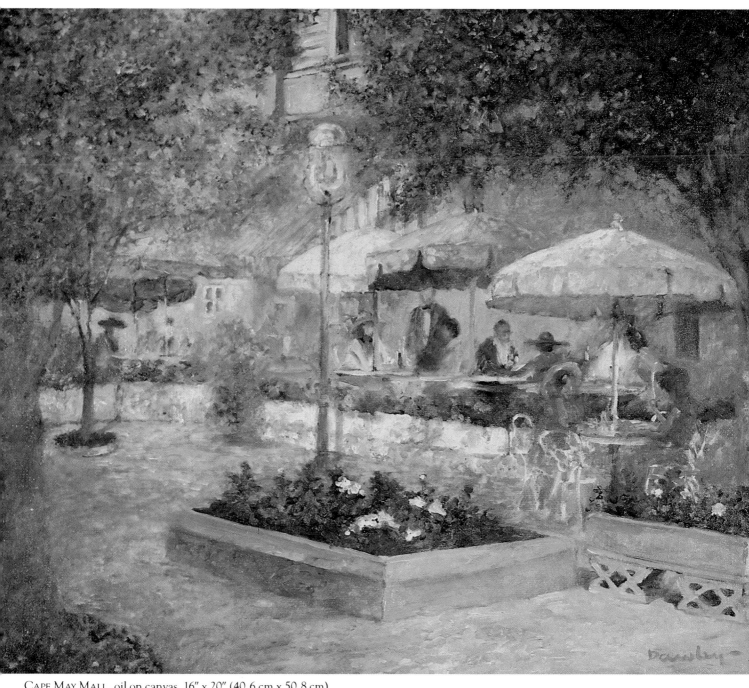

CAPE MAY MALL, oil on canvas, 16″ x 20″ (40.6 cm x 50.8 cm)

Light and Values Affect the Composition

I didn't like the heavy shadows in the foreground of this photograph, but it was all I had to work with. I got the shapes and composition from the slide, then figured out where I wanted the sun to be, that is, from which direction the light should fall to create the effects I wanted. Then I combined the information from the photo with my knowledge, from experience and observation, of how light shapes organic forms, to paint the garden as I wanted it to appear.

The painting was to have been of figures in a garden, but when it was almost finished, I realized that the figures just didn't work. There were too many of them and they were too conspicuous—since almost all of them were dressed in white, they really stood out.

I solved this problem by eliminating most of the figures and subduing those that remained. Lowering the value contrast integrated them better into the overall picture. The umbrella in the background was also too prominent; I wanted it to harmonize better with the colors around it. I used trial-and-error for this area, painting in different colors until I found one that worked.

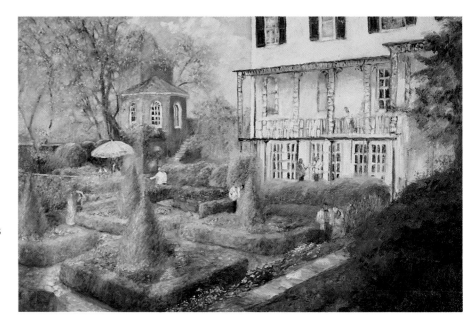

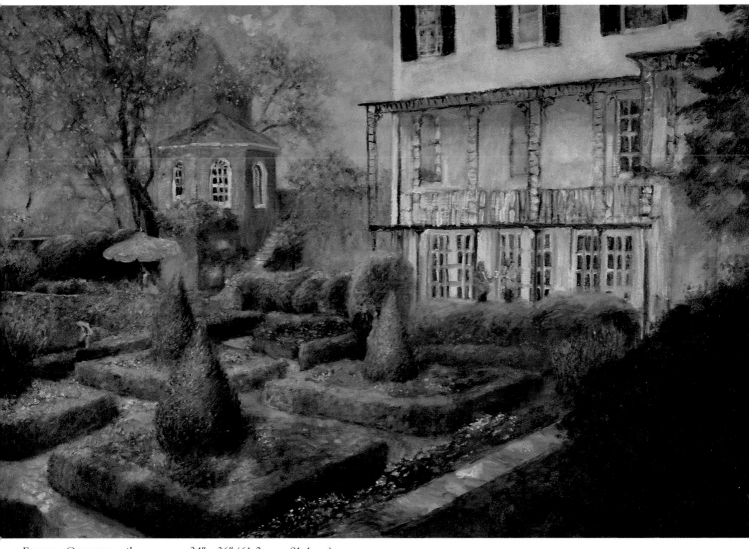

FORMAL GARDENS, oil on canvas, 24″ x 36″ (61.0 cm x 91.4 cm)

Bright Colors Animate a Busy Scene

The photograph I used for this painting was not very colorful or exciting; I used my imagination to add people and color—in other words, to bring the scene to life.

I used permanent mauve for the framework of the building that stretches across the left half of the painting; touches of that color spill over into the foreground, the shadows, and the clothing of the figures. The tree trunks contain ultramarine blue, ultramarine violet, and yellow ochre; these colors not only work well together but also harmonize with the permanent mauve. The main colors in the leaves are sap green, chromium oxide green, yellow ochre, and white. I scattered small strokes of the other colors of the painting throughout the trees. I removed some of the leaves to allow the blue of the sky to show through; if I hadn't done so, the masses of dark foliage overhead would have had a heavy, overbearing effect.

I saved my brightest colors for the figures, who are painted in a variety of bright reds, blues, yellows, and purples. White highlights pick out the forms of the tables and chairs. The figures are loosely painted, suggested rather than delineated. The viewer has to step back from the canvas to make sense of it; even then, imagination is an important component of impressionism.

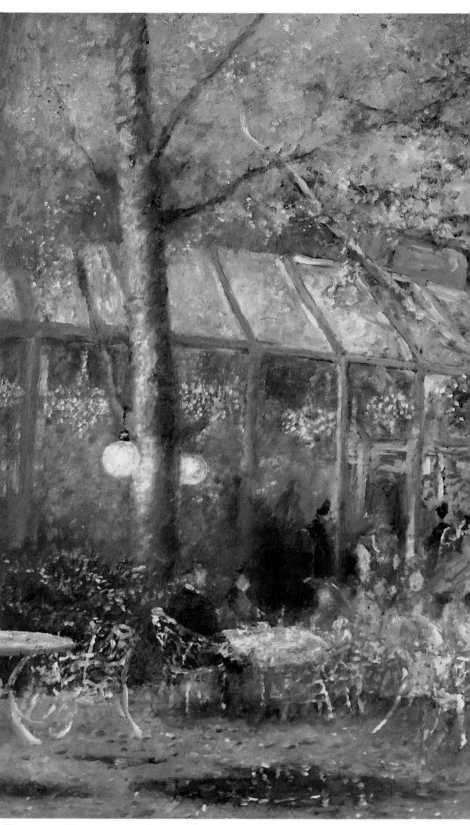

TERRACE OF TAVERN ON THE GREEN, oil on Masonite, 30" × 36" (76.2 cm × 91.4 cm)

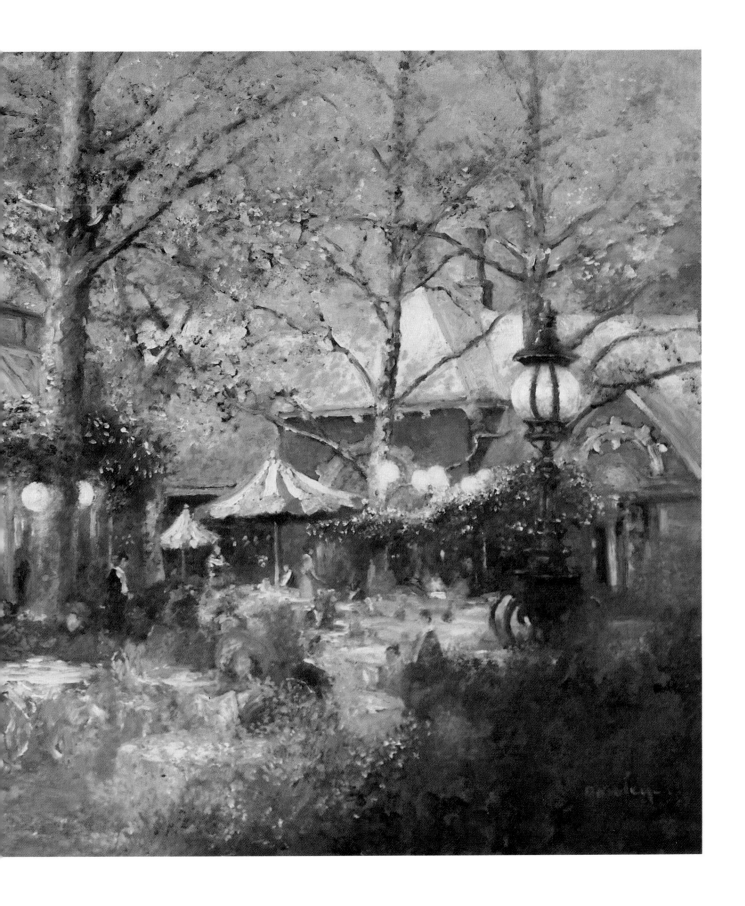

Using Complementary Colors

Complementary colors are pairs of colors that appear opposite each other on the color wheel: red and green, purple and yellow, blue and orange. In each of these pairs, one color is a primary and the other is the combination of the other two primaries. Therefore, when you mix complementary colors together on the palette, the result is a neutral gray. Placed side by side in a painting, however, they strengthen each other—sometimes too much. High-intensity complementaries can be jarring and unpleasant. If the colors are modulated, though, the effect can be very pleasing indeed.

When I painted this picture, I didn't follow the colors in the photo at all. Instead, I devised my own color scheme, which is based on two complementary pairs: purple and yellow and red and green.

The first pair is the more obvious: The men's vests are brilliant purple; the tablecloth, cheese, and background are vibrant yellow. There are subtler touches of purple in the broken color of the foreground and background.

Most of the red-green interaction occurs in the pink bush in the foreground, where myriad small spots of pink seem to float over a green underpainting. The green wine bottle commands a great deal of attention because of its central position; it is balanced by the red areas in the wineglass and the background.

When purple sits next to yellow, it seems brighter; when they are blended together, the result is gray.

A green underpainting makes pink brushstrokes glow with color.

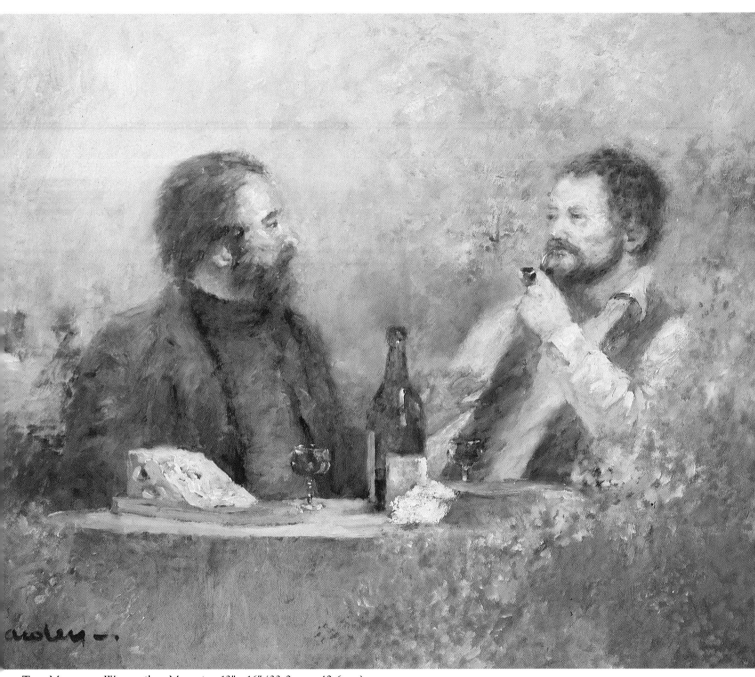

Two Men with Wine, oil on Masonite, 13″ x 16″ (33.0 cm x 40.6 cm)

Using Tertiary Colors

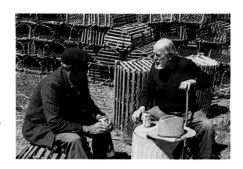

We usually think of the color wheel as consisting of the primary colors (red, blue, yellow) and the secondary colors (purple, green, orange) created by mixing the primaries. There is another group of colors, the tertiaries, that is useful for constructing color schemes. These fall between adjacent colors on the color wheel—red-orange, for instance, is the color between red and orange.

The pair of complementary colors around which this painting is constructed is a pair of tertiary colors: red-purple and yellow-green. The red-purple area lies right in the center of the painting; the yellow-green is dispersed around the periphery, in the small brushstrokes that make up the foliage. There is another complementary harmony on the left: yellow leaves in front of a violet jacket.

Note that in the original photograph, the man holding the cane was wearing a maroon sweater. This was too large an area of red-purple—it threw the colors out of balance—so I added the dark jacket to reduce the area of color.

The reference photos from which this was painted were taken during a Fourth of July picnic in Maine; the lobster pot steaming in the background at right was taken from another photograph of that picnic. I put it in because preparing and sharing food has always seemed to me to symbolize camaraderie and pleasure between friends, and also because I love boiled lobster.

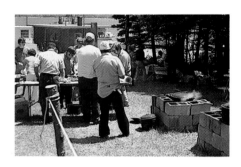

Red-purple and yellow-green are tertiary colors that form a complementary pair. This results in a subtler harmony than one formed by a primary and a secondary color.

A more obvious complementary pair, yellow and violet flowers, lies off to one side.

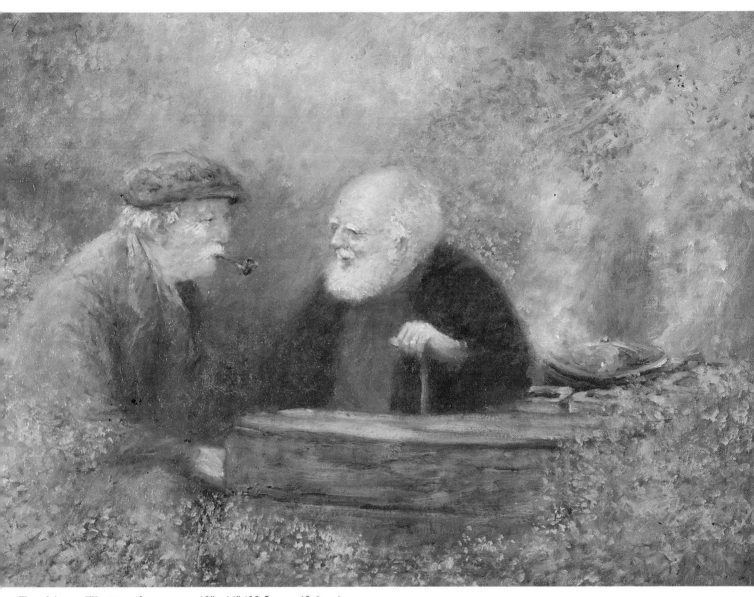

TWO MEN IN WOODS, oil on canvas, 12″ x 16″ (30.5 cm x 40.6 cm)

Experimenting to Develop Color

The composition of this painting didn't present any problems: I decided to use the girl in red from photo A and the girl in white from photo B, placing them against a simple background of diffused colors. I wasn't sure what colors to use for the background and the dress of the girl on the left. In order to resolve these problems, I did a series of quick color sketches.

In the first sketch, I tried keeping the original red color for the dress, using a blue background to balance the lightness of the girl in white. I could see that this would result in gaudier colors than I wanted.

Next, I tried an orange background and changed the dress from red to purple. This solution didn't seem to work either, so I left a touch of blue between the girls to see how it would work with this color scheme. I could see from the sketch, however, that the skin tones didn't work with the orange and purple.

In the third sketch, I tried a complementary pair: a yellow dress against a purple background. I added some touches of turquoise, but I could see that the skin tones were still striking a discordant note with these pastel colors.

Finally, I tried a low-intensity blue for the dress and set it against a muted white background. This proved to be a workable color combination, so I used it in the final painting.

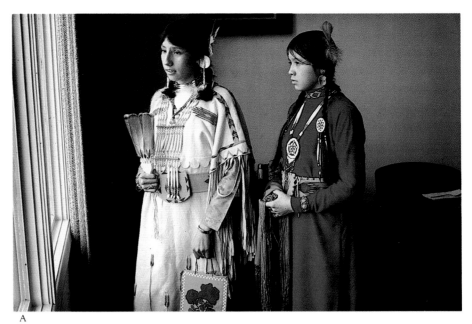

A

B

Experimenting to Develop Color

Once I had the basic color scheme worked out, things fell into place fairly easily. I wanted to make the two costumes complementary and harmonious, rather than draw attention to their differences. I toned down the colors of the embroidery on the white dress so it wouldn't overshadow the other, plainer dress. The blue I used for the right-hand girl's sleeve is similar to the blue of the other girl's dress.

The background was meant to suggest an outdoor scene; I used cool, springlike colors, blues and greens with touches of purple and yellow ochre, but I wasn't totally happy with this resolution.

After living with the painting awhile, I decided the background needed to be livelier. I added bright colors—cadmium yellow in the upper area, permanent mauve and cobalt violet on the left, cadmium red light, cadmium red medium, and toned-down yellow ochre on the right. I used strong vertical strokes to add a sense of vigor and motion to the area. Now the painting conveys the mood I was trying to capture.

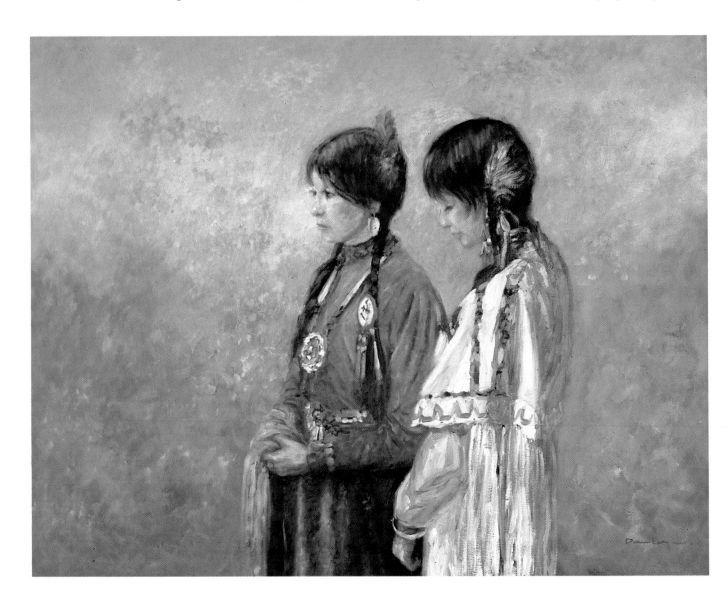

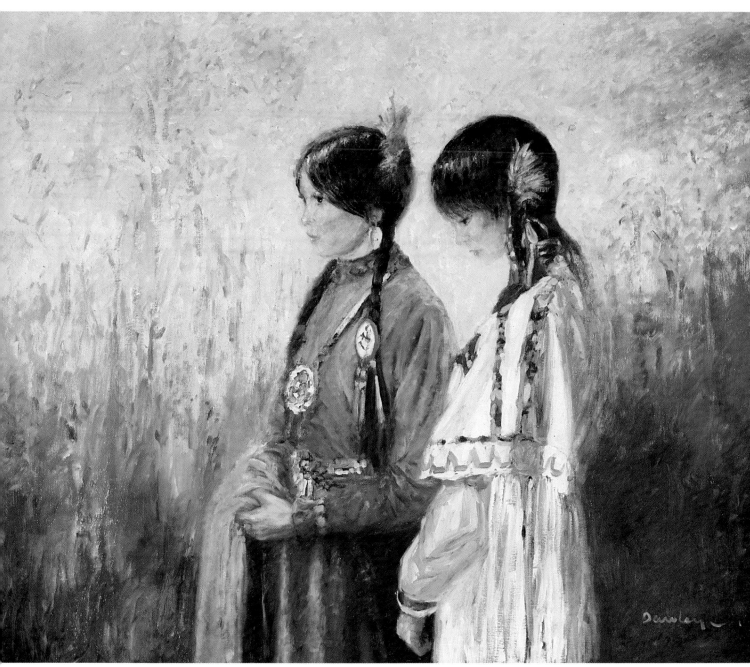

INDIAN GIRLS IN FALL, oil on canvas, 30″ x 36″ (76.2 cm x 91.4 cm)

Complementary Colors Brighten a Character Study

This is not a portrait; I didn't set out to do an exact likeness of the girl in the photograph. Rather, I used the photo as a starting point for a character study and changed her features to harmonize with the rest of the painting. Actually, I liked the way the girl looks in the photograph—she seems very forlorn and serene—but I was looking for a happier mood, and the painting evolved into a fantasy picture.

The outstanding feature that I didn't change was the vivid blue of her eyes; in fact, this determined much of the rest of the painting. I decided that changing her hair color to blond would set off her eyes better. I painted her hair with long strokes of different colors—yellows, greens, purples, blues, browns—that all add up to the impression of blond hair. This is a good way to handle hair because the color is never consistent anyway. Look closely at someone's hair and you will see a variety of shades. Broken color is a good way to depict this.

The background on the left gradually changes from blue to purple, which, as the complement of yellow, brings out the golden quality of the hair. The yellow-purple complementary pair is restated, more explicitly, in the flowers in the lower left corner.

There are touches of blue all over the painting: the background, the barrettes in the girl's hair, the folds of her dress, the foreground flowers. These not only echo the blue of her eyes but also bring a glow to her skin tones, because blue is the complement of orange, and orange, made up of small strokes of reds and yellows, is the predominant color of her skin.

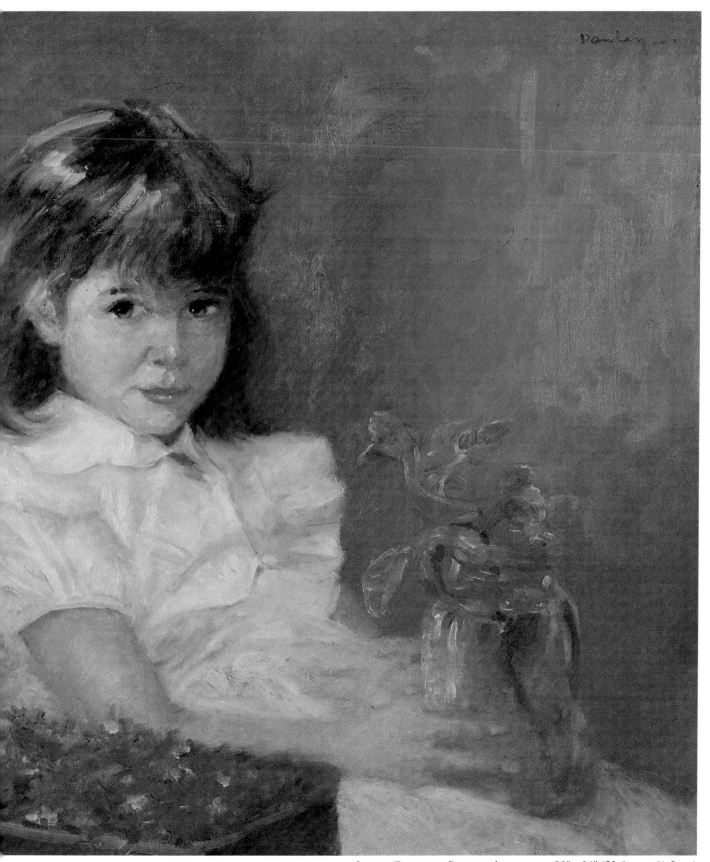

LITTLE GIRL WITH PLANT, oil on canvas, 20″ x 24″ (50.8 cm x 61.0 cm)

Using Low-key Complementary Colors

The predominant colors in this painting are blue and orange, which are a complementary pair. Complementary colors can be very jarring when they appear together at high intensities; this painting works because the colors are fairly neutral.

I painted this from a single photograph. It was very cluttered, so I selected just two geese and adjusted their positions so the composition would be balanced.

The blues in the water are ultramarine blue, which is a very pure blue, and phthalo blue, which has a greenish undertone. These colors, set off by the yellow and orange leaves, worked well together. The brushwork in the water is fairly loose, permitting me to describe individual reflections and dancing light. I eliminated the leaves and tightened up the brushstrokes in the ripples around the geese.

When the paint had dried, I went over the background with a thin glaze of ultramarine blue and raw umber mixed with a lot of medium. I brought the glaze about halfway down the painting, which darkened the area and reduced the intensity of the colors. Then I wiped the glaze off some of the leaves to bring back the color a bit. When it was just right, I put in more leaves—just touches of yellow and orange. These sit on top of the other paint surfaces and really do appear to be floating.

Loose brushwork and low-key blue and orange give a feeling of depth to the water. The leaves are touches of paint sitting on the surface of the painting; they appear to be floating.

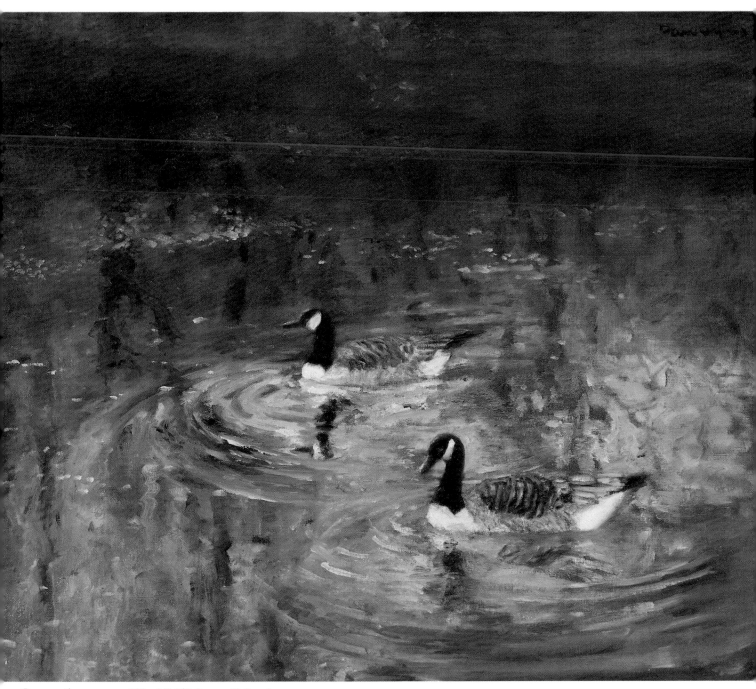

GEESE, oil on canvas, 20″ x 24″ (50.8 cm x 61.0 cm)

Muted Colors Evoke a Lonely Mood

The predominant colors in this painting are the three primaries: red, yellow, and blue. Usually color schemes based on the primaries are very bright, but the colors here are pale and low-intensity. The mood is tranquil, perhaps a little sad.

I mixed a lot of white into the colors, and except for the sky, all are on the cool side. The sky color is echoed in the highlights of pure yellow in the buildings and on the water. I used blue for the shadows, particularly on the houses; it adds to the chilly atmosphere.

The painting can be divided into three horizontal bands of color. The sky is yellow; the buildings are dominated by a cold pink mixed from cadmium red medium and white; the underlying color of the water is blue. This division is clearer on the

right; on the left, the buildings rise to meet the viewer, and the pilings and dock conceal the water line. Nonetheless, there is a strong horizontal emphasis in the composition that adds to the calmness of the scene.

The reflections in the water are subtle; the brushstrokes are long and blended, the colors are not very intense, and the contrasts are not very strong. The horizontal brushstrokes reinforce the lines of the composition.

The gondolas are the focal point of the painting; they attract attention because of their position (in the middle of the canvas) and their value (the darkest area of the painting). The few gondoliers are the only figures in this scene; their presence makes it lonelier than if there were no figures at all.

Reflections on the water are long, blended strokes of muted color.

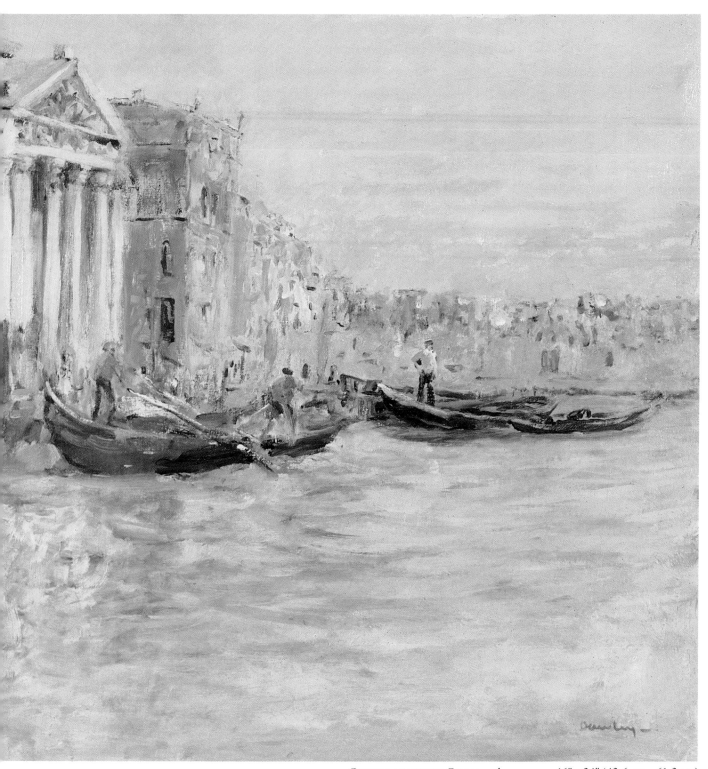

GONDOLAS ON THE CANAL, oil on canvas, 16″ x 24″ (40.6 cm x 61.0 cm)

Neutrals Enhance Bright Colors

"All color is no color," one of my teachers used to say; his point was that if you use too many bright colors, they will cancel each other out. Strategically placed neutrals, on the other hand, will bring out the intensity of your colors. I applied that principle here, using dull colors for the buildings to play up the vivid sea and sky.

Many painters like to use earth colors for this purpose, but I prefer to mix my own neutrals from the primaries—red, yellow, and blue—often letting one dominate just a little. This creates a fairly neutral mixture with a hint of primary color. I create gray, for example, by mixing yellow ochre and ultramarine blue, then adding enough white to give me the correct value. Sometimes I add a little permanent mauve for a warm gray. For brown, I use ultramarine blue, yellow ochre, and cadmium red light or medium, again adding white as needed.

When the component colors are not mixed on the palette but are used directly on the canvas, they retain their brightness, as you can see here: The neutrals I used for the houses were mixed from the same pigments I applied in broken-color fashion to the sky and water.

I experimented quite a bit before I arrived at my final color scheme; the sketches on the next two pages show the trial-and-error process I went through.

There are a number of different grays in these buildings, and each one has a different color.

When contrasting colors are applied in individual strokes, rather than mixed on the palette, they retain their brightness.

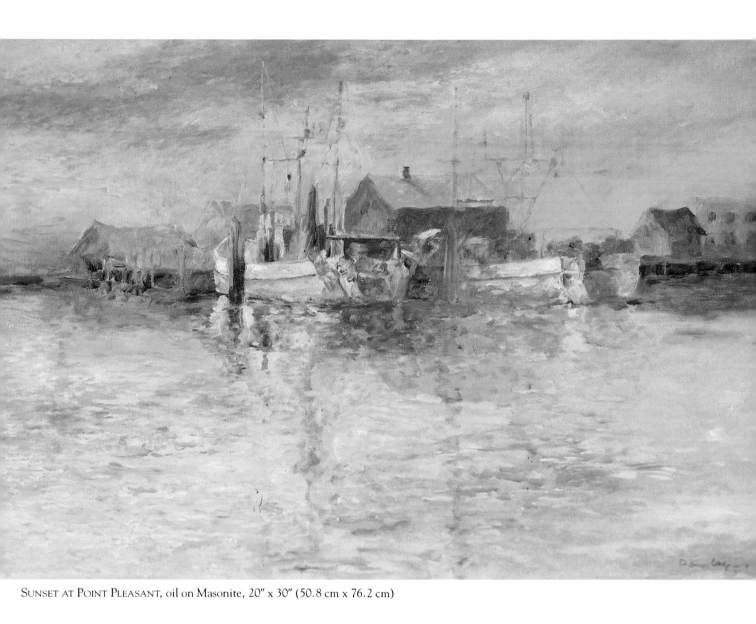

SUNSET AT POINT PLEASANT, oil on Masonite, 20″ x 30″ (50.8 cm x 76.2 cm)

Neutrals Enhance Bright Colors

I started with a predictable color
scheme: ultramarine blue lightened with
white for sky and water. I decided this
didn't have enough impact.

This time I tried phthalo blue for the
water, with some orange lightly brushed
in at the bottom to see what a sunset
effect would be like. This seems to work
better.

Now I used a lot of orange and purple to really give the impression of a sunset; I kept a little blue in the water for contrast.

I went all out here and concentrated on the orange and purple, with some yellow in the sky that is picked up by the water. I liked both this and the previous sketch, and I used both in the finished painting.

Using Adjacent Colors

Hues that lie next to each other on the color wheel are known as adjacent colors. Pairs or groups of these colors tend to produce subtle, pleasing harmonies, as opposed to the strong and sometimes disturbing contrasts created by complementary colors. This painting is dominated by blue, green, and various shades of blue-green. The coolness and harmony of the color scheme contribute to the serene atmosphere of the painting.

For the sky and water, I used ultramarine blue, phthalo blue, and white. The two blues were combined in the sky, and they work well together. In the water, the brushstrokes are side by side and the colors are separate, so they work against each other. This creates tension and motion in the pool; it makes the surface of the water seem choppy.

The predominant green in the trees was chromium oxide green, with ultramarine violet or permanent mauve brushed into it to produce browns and shadows. I also used mixtures of chrome green and yellow ochre in some areas and viridian and yellow ochre in others.

One of the pitfalls of adjacent-color schemes is monotony. I brought in two subtle warm touches, the brownish yellow roof on the left and the red flowers on the right. These accents perk up the colors a bit and add variety. I also used some muted purples in the sky and shadows.

REFLECTING POOL AT WASHINGTON, oil on canvas, 24" x 36" (61.0 cm x 91.4 cm)

Light and Color Control Depth of Field

In this painting, I used strong sunlight and bright colors to evoke the cheerful atmosphere of the sidewalk cafe in the photo.

The strongest value and color contrasts occur in the foreground. Bright sunlight hits white objects (the umbrellas, the window) and creates strong silhouettes against the dark background. Touches of strong color sparkle in front of the darkness. The bright red flowers lie on a bed of green; the complementary colors strengthen each other.

As the eye moves deeper into the background, values move closer together and colors become less intense, so that the contrasts are reduced. Another complementary pair in the background—a purple umbrella in front of a yellow building—has less punch because the colors are more neutral. Figures dissolve into a haze of misty color.

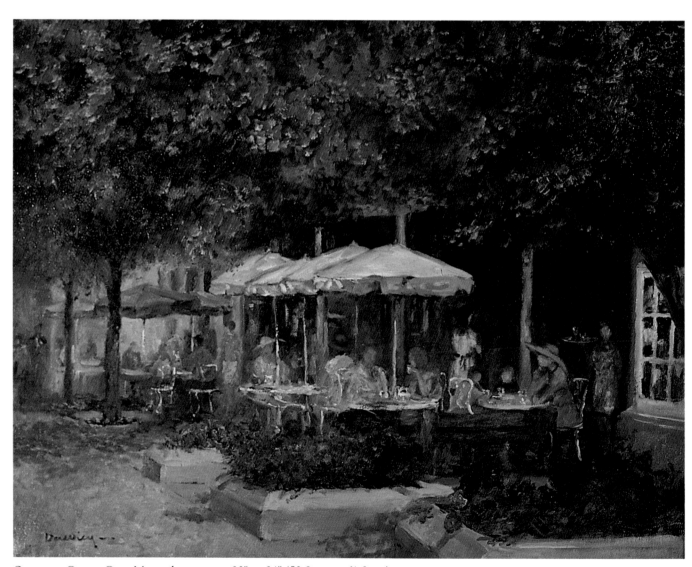

OUTDOOR CAFE—CAPE MAY, oil on canvas, 20″ × 24″ (50.8 cm × 61.0 cm)

Subduing Strong Light

I felt the light in this photo was too strong, too harsh. I wanted to soften this scene into a pleasant, harmonious, restful painting.

My first step was to change the composition: By cutting out a portion of the foreground and the right side of the image, I narrowed the focus down to the buildings and the outdoor cafe and also eliminated large areas of pale, featureless sidewalk.

I tried to keep the values in the middle of the scale and the colors varied but subtle. I added a variety of colors to the buildings, but the intensity is fairly low, so they are colorful but not bright. A few spots of vibrant color—the red and yellow near the center—and a few crisp whites—the umbrella, the menus, the white shirt—add sparkle and keep the subdued hues and values from becoming monotonous.

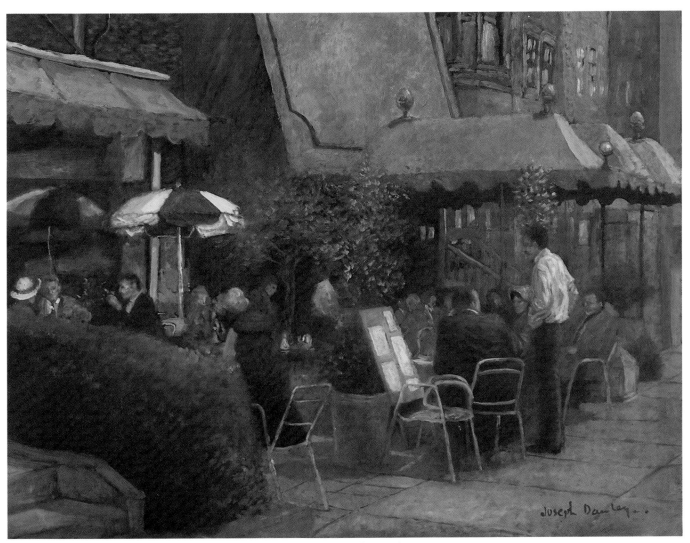

SIDEWALK CAFE—WASHINGTON, oil on Masonite, 14″ x 20″ (35.6 cm x 50.8 cm)

Sunlight and Shadow

The effect of bright sunlight is achieved here by using strong highlights to pick out a few strategically placed details. The subject matter in this case, the National Cathedral in Washington, DC, lends itself to this technique because its elaborate architecture breaks up light and shade nicely.

I have used two basic colors (although they contain touches of other colors) for the surface of the cathedral: a yellowish white where the sunlight directly hits the wall and a darker violet for the shadowed areas. Value contrast is enhanced by color contrast, since yellow and violet are complementary colors. Because yellow is a warm color, the highlights convey the warmth of sunlight, and because warm colors seem to advance toward the viewer, they appear larger than they really are. The cool violet, on the other hand, evokes the cooler shadows and recedes from the viewer. This dramatic lighting sets the mood of the painting.

The arched windows and doorways are very dark, but there is some color in the rose window. I studied the rose window from inside and outside the cathedral. Obviously, it looks much better from the inside, when the light is pouring in through the stained glass. From the outside, it just looks like another dark window. In this painting, I used the colors I had seen inside the church, but I kept them muted and dark so they wouldn't appear unusual or out of place. The predominant colors in this area are red and blue—the components of violet.

The tree that partially blocks the view enfolds the cathedral in its pink blossoms and links the background and foreground. Note the subtle use of complementary colors (pink blossoms, green leaves) in this area. The tree seems to fade back into the building in the leafy areas, where colors and values are very close, but the trunk and branches are pushed forward by their sharp contrast with the sunlit wall.

Warm yellow highlights and cool violet shadows create the impression of form and light with a few simple planes of color.

NATIONAL CATHEDRAL, oil on Masonite, 12″ x 16″ (30.5 cm x 40.6 cm)

Sunlight Falling Through Foliage

Most of the information I needed was already in the photograph; the changes I made in the painting process were subtle.

The sunlight is most intense, of course, in the trees, so I concentrated the strongest light effects there. I painted in the masses of leaves in various greens and then added strong pale yellow highlights for the sunlit effect. Notice that the visible branches on the center tree, where the light is strongest of all, are purple. Since purple is the complement of yellow, color contrast here intensifies the yellow; there is also a sharp value contrast between the light leaves and the dark branches. The tree on the right-hand side of the canvas, which is farther back and less central to the picture, is handled more subtly.

The sunlight that filters through the trees is weakened a bit; it is carried through the scene by the white and pale yellow highlights on the roof, the awning, the sidewalk, and the bushes.

I added to the overall brightness of the scene by intensifying the colors, making the slate roof bluer and carrying the red of the building through the canopy and over to the seats of the hansom cab. I eliminated the white lettering and designs from the awning so they wouldn't detract from the white highlights or make the scene too busy. The path and road are painted in a multiplicity of colors that add up to blue and purple.

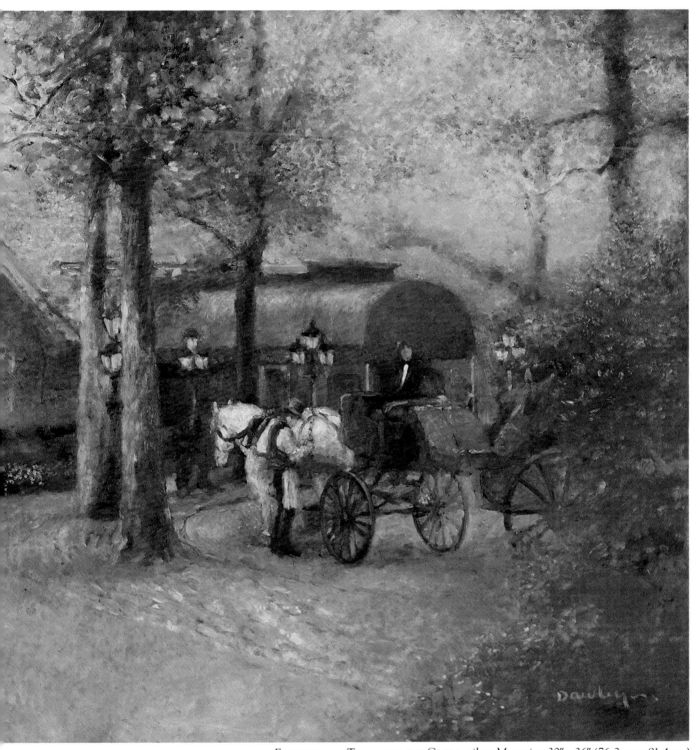

ENTRANCE TO TAVERN ON THE GREEN, oil on Masonite, 30″ x 36″ (76.2 cm x 91.4 cm)

Using Broken Color to Paint Fall Foliage

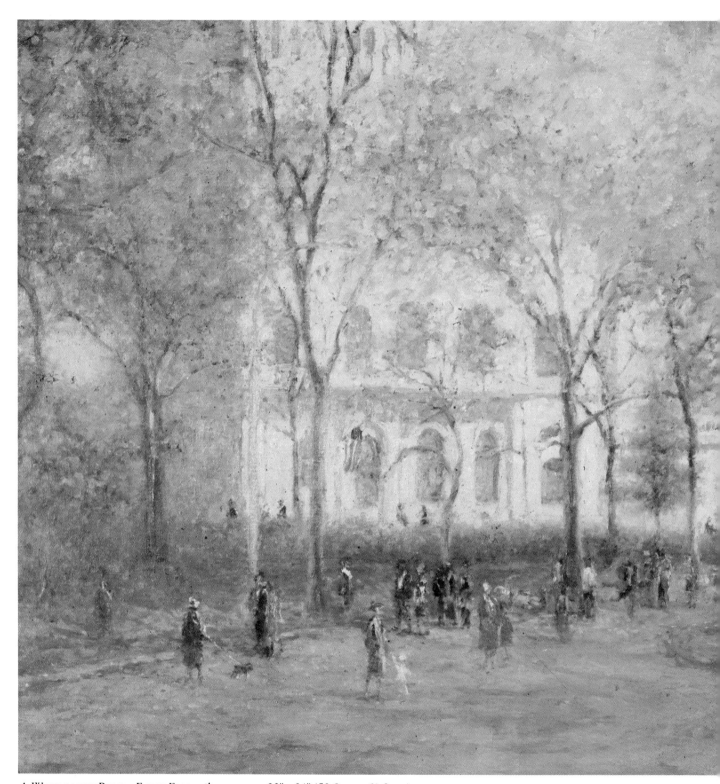

A WALK IN THE PARK—EARLY FALL, oil on canvas, 20″ x 24″ (50.8 cm x 61.0 cm)

The trees really dominate this painting; they set up a beautiful gradient across the canvas. The reference photo was not a fall scene, but I changed the season to increase my color choices. The red at left is so cool it's almost purple; next to it, the tree in the center bursts forth in bright yellow. The foliage gradually shifts to a deep orange-red on the right. I used the broken-color technique to achieve bright, rich colors; this method is ideal when I want to change the hue gradually across a surface, as I did here.

When I paint the full, green foliage of spring and summer, I use fairly large, dense brushstrokes; here they are smaller and farther apart, to depict the sparseness of fall leaves and to increase optical mixing. When I lay brushstrokes of two different colors side by side, the eye blends them into a new color; thus, to the right, individual touches of cadmium red medium and cadmium yellow deep melt together to form a shimmering mass of orange.

I changed the photograph in other ways, pulling in closer to the building and trees and adding the pedestrians. The mood has shifted from an almost featureless photograph to a quietly colorful painting of Sunday morning serenity.

Capturing Reflections on Water

The pictures I took on a rafting trip down a river in Jamaica are the basis for this painting and the two that follow. Unfortunately, there had recently been heavy rains in the mountains, so the river was very muddy—much more so than usual. When I painted from the photographs, I had to add color and clarity to the murky water.

The man in the foreground of all of these photographs was guiding the raft; I eliminated him from the paintings and concentrated on the rafter in the distance, who I found much more interesting. I also left out the tourists, as their presence detracted from the scene.

The wedge of sky appearing between the greenery of the two banks is what attracted me to this scene. I didn't want the overhanging effect of the trees to be too confining, so I broadened the triangle of sky and lightened and brightened the foliage to give the impression of light rushing through it. I also placed two separate branches of greenery in the upper left corner.

There are two blues in the sky: ultramarine blue and phthalo blue, both mixed with white. I added tints of permanent mauve and cadmium orange—the latter color in the clouds only. I blended the brushstrokes fairly carefully for a smooth, atmospheric appearance.

The water, on the other hand, is painted with broken color to capture the shimmer of the reflections on its surface. I used cerulean blue in this area because it makes the orange come up a little stronger. The orange of the clouds is more prominent here than in the sky. The reflections of the trees are roughly the same colors as the trees themselves, but the intensity is reduced somewhat and the brushstrokes are more horizontal. Subtle highlights of white and pale blue define the surface, giving depth to the murky greens.

The sky is painted in carefully blended strokes of ultramarine blue, phthalo blue, permanent mauve, and cadmium orange.

The water is painted in broken-color fashion—small strokes of cerulean blue and cadmium orange.

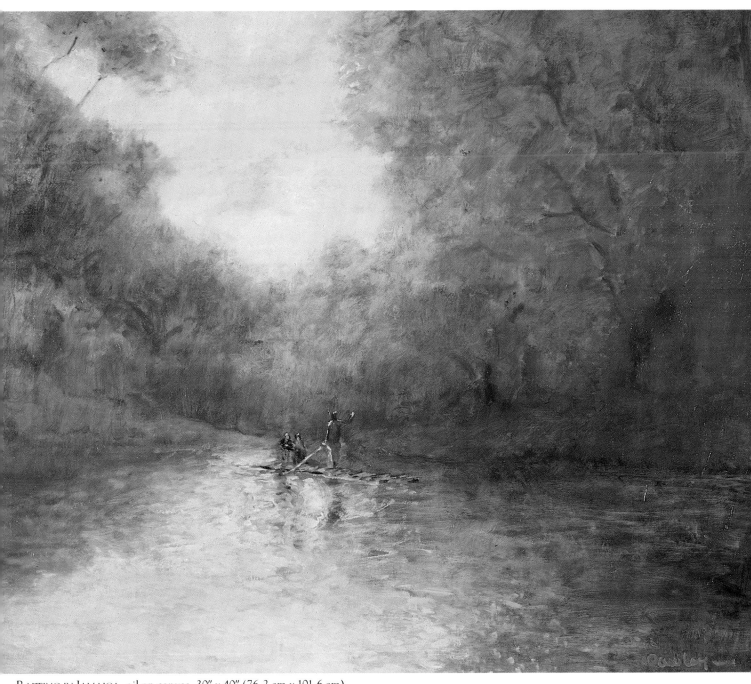

RAFTING IN JAMAICA, oil on canvas, 30″ x 40″ (76.2 cm x 101.6 cm)

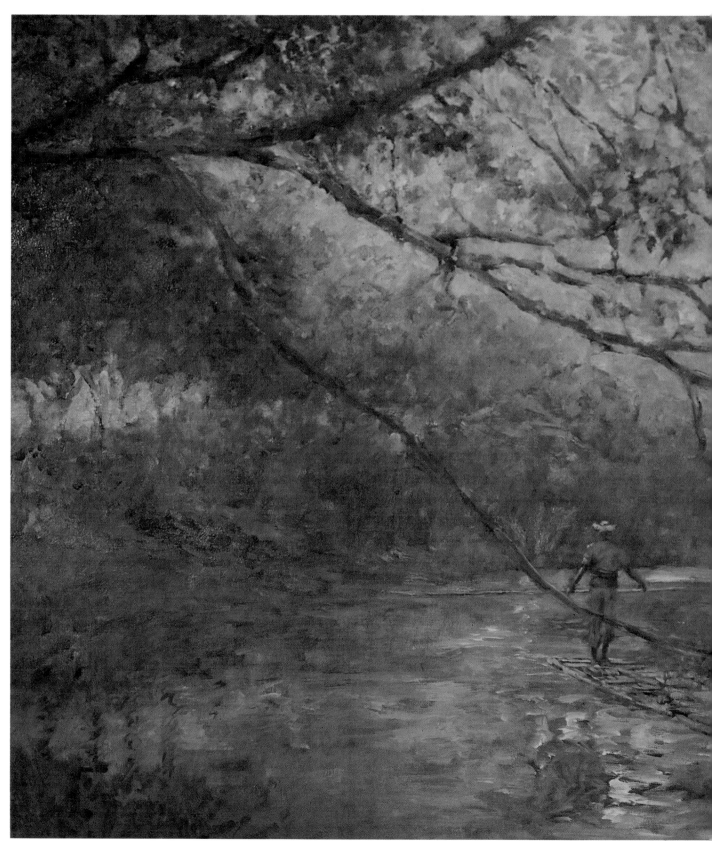

Rafting, oil on canvas, 24″ x 36″ (61.0 cm x 91.4 cm)

The color and composition of this painting are much more complex than those of the preceding one.

The scenery in this painting came from photo A, the rafter from photo B. I liked this figure so much that, apart from his hat, I painted him exactly as he was in the photo.

There are hints of rose and purple in the sky; I didn't blend the brush-strokes much in this area, but because the values of the various colors are so close, it appears fairly smooth. The foliage is painted very loosely in a variety of greens, yellows, and blues. I brought some of the sky colors into the greenery to help unify the painting, and I let the sky show through the trees at left, as it does in photo A.

The reflections in the water are fairly clear—the tree trunks on the left, for example, show up distinctly in the water. There is a greater variety of colors than in the previous painting, and the brushstrokes show up better. I used squiggles of white in places, especially down the center of the painting, to emphasize the sparkle and motion of the water.

A

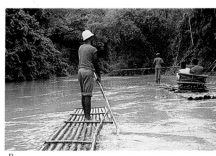

B

Capturing Reflections on Water

This is the largest of the river paintings, and it is the richest in color and texture. The setting came from photo A, but I used my imagination to really bring it to life. The rafter came from photo B; he is the same man as in the other two paintings, but this time I clothed him in a white serape that seemed to fit in with the design and color scheme.

I opened up the landscape by showing the sky above the trees and in the distance. The sky is suffused with brilliant colors—blue, orange, rose—that are picked up and echoed by the river and the trees.

The reflections in the river are warmer here than in the previous two paintings because the water is picking up more foliage than sky. Thus, the colors are greens, oranges, yellows, with horizontal strokes of blue to delineate the surface. The sky is reflected more strongly in the distance, where blue and rose blend into a lovely haze.

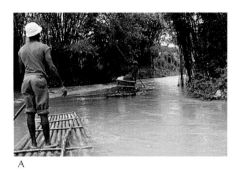

A

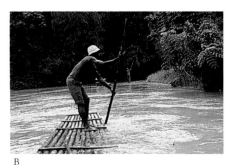

B

WASH DAY, oil on canvas, 40″ x 56″ (101.6 cm x 142.2 cm)

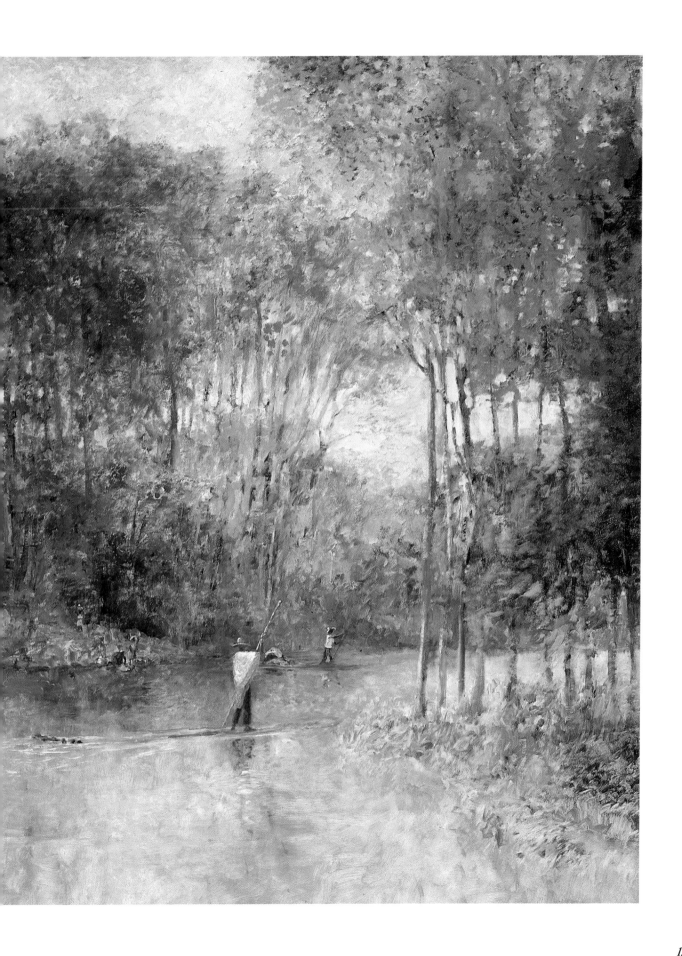

Blending Color with a Palette Knife

This technique can only be used on a large painting, but it is a very effective way to apply and combine colors.

The colors I have used here are ultramarine violet, cobalt blue, cerulean blue, Naples yellow, cadmium red light, and viridian.

My first step is to lay out the colors on a piece of cardboard, which absorbs the oil. This changes the consistency of the paint, making it tackier and easier to work with. I dab the paint on the cardboard with a palette knife in the manner shown on the right, but quite thinly, so the oil will seep out faster.

When I am happy with the consistency of the paint, I dab the colors on the canvas. Then I take a four-inch putty knife and twist it through the colors. This creates interesting designs and combinations; when I get the desired effect, I stop.

This is definitely a hit-or-miss technique, and it's important to know when to stop. Overworking the paint results in a muddy effect; if this happens, I just wipe it off and start over.

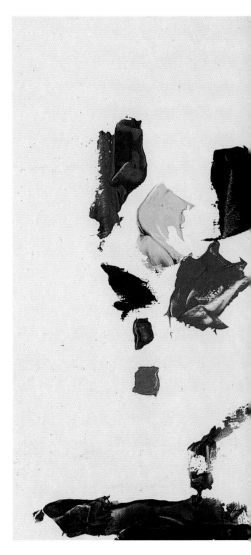

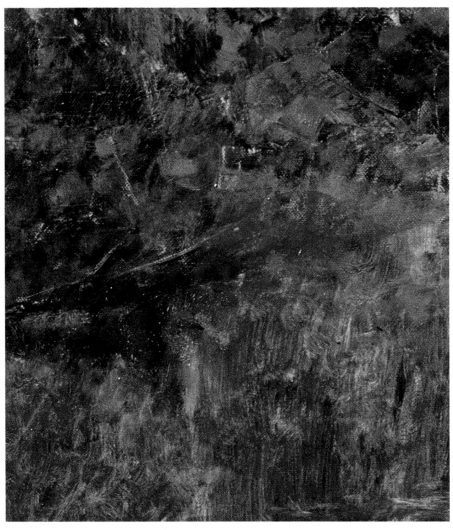

I used the technique described above on this portion of the riverbank in the painting on pages 124–25. Note the dappled colors and the arcs made by the putty knife.

Capturing the Motion of Flowing Water

My main concern throughout this painting was to capture the spirit of the scene in the photograph below, particularly the motion of the water.

For the rocks and water, I began with a colorful underpainting in alkyd paints. I chose alkyd rather than oil paints for this step because they dry quickly, so I can build up multiple layers in a short time. I used orange, blues, and purples for the underpainting, keeping the colors very bright.

My next step was to go over all these areas with white oil paint. I scribbled with the brush, using long strokes to depict the flow of the water. This scrubbing technique, called scumbling, allowed some of the bright color to show through the white. Even those rocks that didn't have water flowing over them got a thin layer of white paint, to unify those portions of the painting.

Sometimes oil paint is easier to control if I let some of the oil out; this gives it a stiffer texture. I do this by smearing the paint on a piece of cardboard with a palette knife and letting it sit until the consistency is right. The amount of time this takes varies with the color and the brand of paint: Some colors, such as Venetian red, stiffen very quickly; others, such as titanium white, take longer. I used this technique in this painting to make the white paint easier to handle.

Another device I used to emphasize the flow of water was to add trees and bushes on both sides of the falls. I used static dots of color for the leaves; their stillness contrasts with the flow of the water and enhances the sense of motion. The extra greenery also adds color and balance.

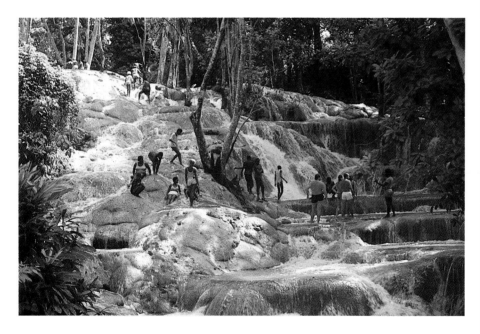

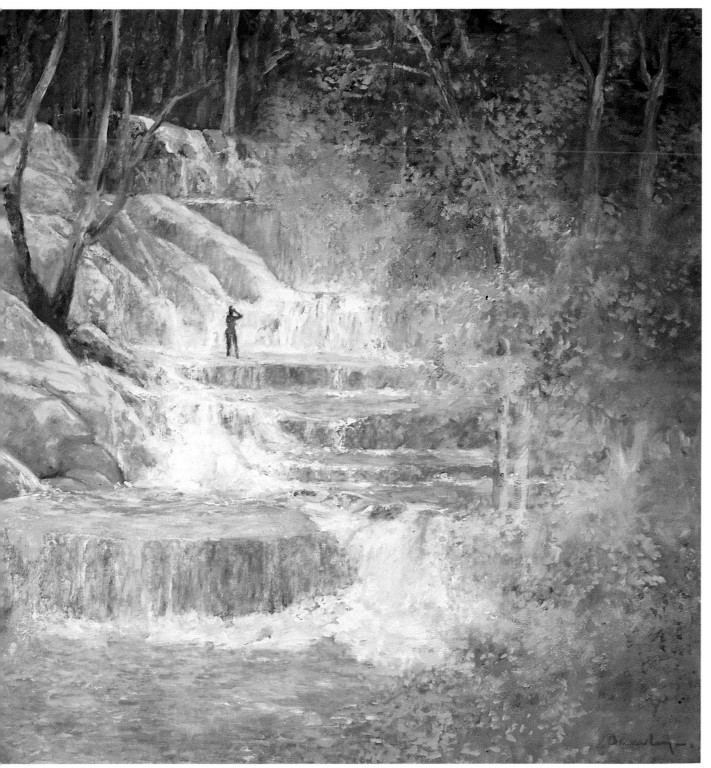

DUNN'S FALLS, oil on canvas, 40″ x 50″ (101.6 cm x 127.0 cm)

The Romance of Rain

I did this painting from one photograph, but I only used those parts of it that fitted the mood I wanted: the carriages, the buildings, the trees. I changed the colors somewhat, using a variety of pastels for the buildings and warm, bright colors for the trees.

After the major elements were established, I decided the atmosphere would be just after a rainfall: The air is clear and the puddles pick up and reflect the colors of the scene. I captured the shiny wet look of the sidewalks with broken color, laying one brushstroke next to another. The directions of the strokes suggest the fluidity of the water. Reflections are both horizontal and vertical. They also create contrast, so I increased color and value contrast in the reflective areas.

I thought the painting was finished at this point, but after living with it for a while, I decided it could be improved.

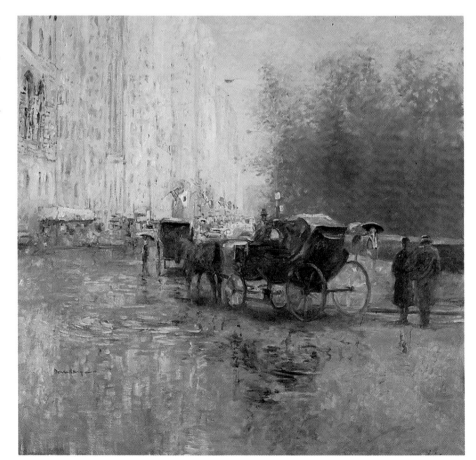

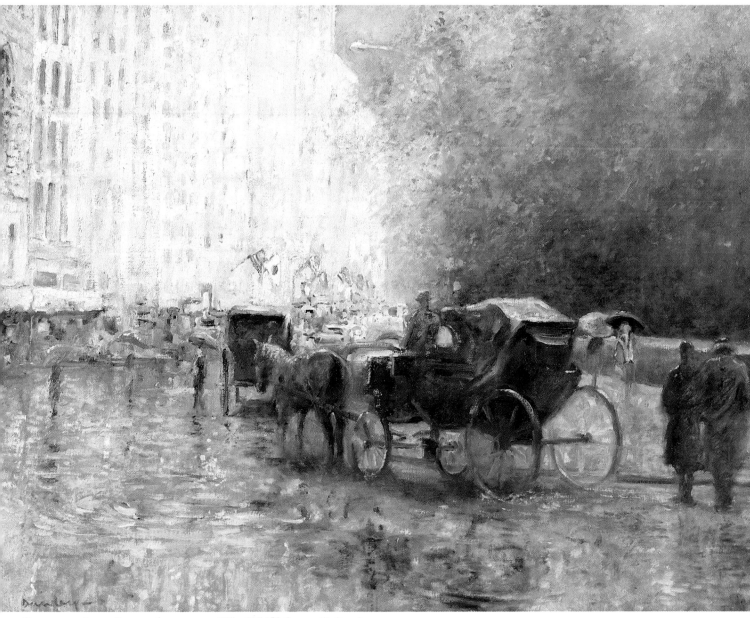

CARRIAGES AFTER RAIN, oil on canvas, 20″ x 24″ (50.8 cm x 61.0 cm)

To begin with, I changed the shape from a square to a more pleasing rectangle. Since the painting was on canvas, I had to take it off the stretcher, cut it down, and restretch it. (Changing the dimensions of a painting is much easier if it is on Masonite, because you can simply saw off the parts you don't want.)

I added more color to the painting and broadened the range of values by bringing in more darks, particularly in the trees. I brought the yellows of the trees down into the puddles and added more color to the wet pavement. A few more pedestrians on the left provided a vehicle for a little more bright color.

Reflections and Color in Windows

The building on the right dominates this painting, and it pretty much dictated the rest of the scene.

The colors and shapes in the windows in the large arches are a combination of the interior showing through and the reflections on the glass. To capture this, I painted the interior views first, then tinted in the reflections—actually overpainting, covering what was already there. I'll go into this in more detail on pages 134–35.

I took the buildings from photos A and B; the space between them seemed to detract from the overall impression, so I moved them closer together. There was a lot of contrast in the photos—too much, I felt— so I deemphasized the shadows and lightened the dark areas, particularly in the building at left. I added a tree on the left to bring some greenery to this concrete-dominated scene, and I added the fountain at right from photo C.

I took bits of the crowd from the photos, but basically I made it up, painting it as one shimmering mass rather than a group of individuals.

A

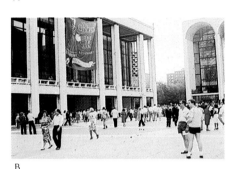

B

C

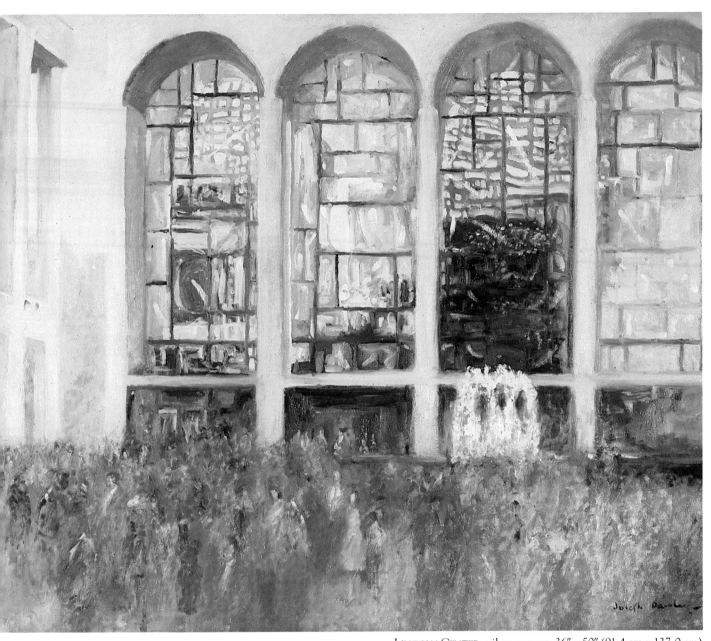

LINCOLN CENTER, oil on canvas, 36″ x 50″ (91.4 cm x 127.0 cm)

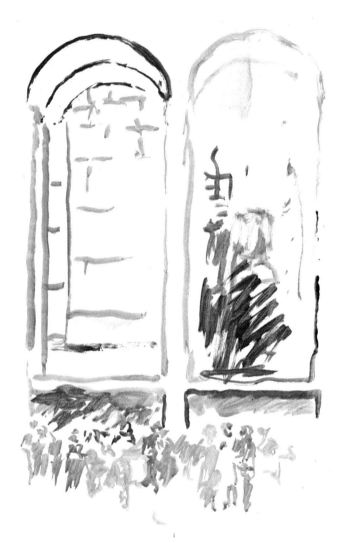

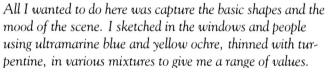

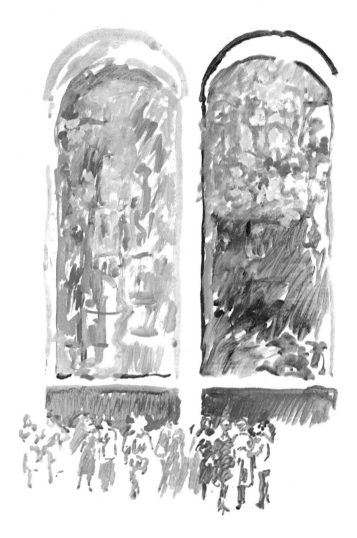

All I wanted to do here was capture the basic shapes and the mood of the scene. I sketched in the windows and people using ultramarine blue and yellow ochre, thinned with turpentine, in various mixtures to give me a range of values.

Now I begin blocking in color areas so I can get the feel and movement of the scene; I'm still working with shapes and values, not details. My palette here consisted of ultramarine blue, cadmium red medium, cadmium orange, yellow ochre, permanent mauve, and white.

Now I start laying in the colors more accurately. For the windows, I used permanent mauve, ultramarine blue, cobalt violet, cerulean blue, cadmium red light, cadmium red medium, cadmium orange, and white. The darks in the window at right are mixed from ultramarine blue and permanent mauve. I used this same mixture to define the shape of the window on the left, lightening the color with cadmium yellow deep.

The people are dotted and stroked in with the same colors as the windows; I also used phthalo green mixed with yellow ochre and white in this area.

Before I started working on surface reflections, I let the previous layers of paint dry almost completely. Then I mixed some blues and whites and brushed this across the windows, using horizontal and vertical strokes; this effect is more pronounced in the window on the right. Also visible in that window is a group of yellow dots, the lights from a chandelier inside the building.

I added more people and kept building up the crowd until it reached the fullness I wanted.

Capturing the Essence of a Building

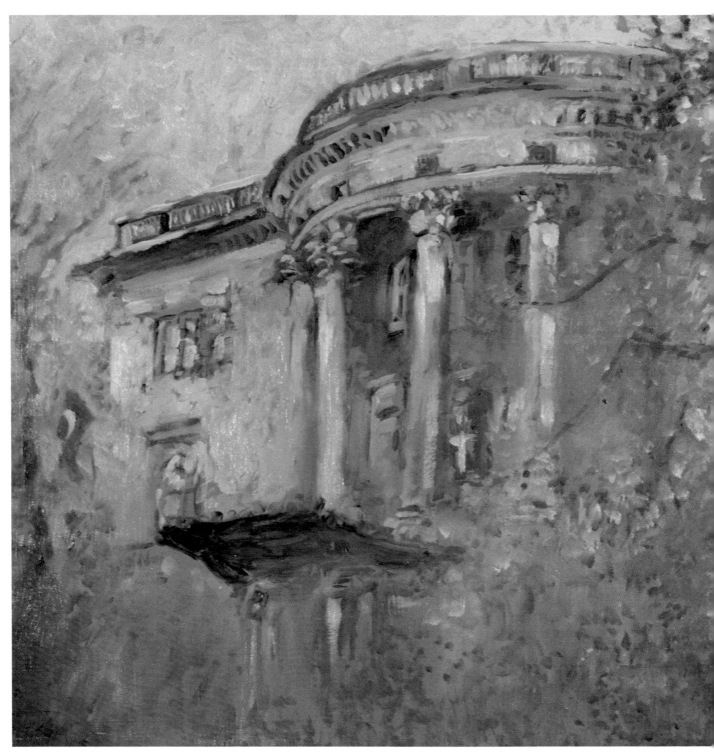

TURKISH EMBASSY, oil on canvas, 12″ x 16″ (30.5 cm x 40.6 cm)

I decided to paint this building because of its shape, which I found very appealing. There is always a temptation, when a building is the subject matter, to treat it as an architectural rendering, drawing in every brick, every detail. I avoided that and concentrated instead on capturing the flowing roundness of the facade.

The basic color scheme of this painting is built around a complementary pair: the deep, intense blue-purple of the building and foliage and the pale, muted yellow-orange of the sky and the light areas. I began by sketching in the building with a blue-gray tone mixed from ultramarine blue and yellow ochre. I simplified the forms of the building and used value transitions to define the form. I worked the light and dark areas simultaneously, rather than building up from one to the other. In the dark areas I used purple mixed from cadmium red and ultramarine blue and

brown mixed from cadmium red, ultramarine blue, and yellow ochre. For the lighter areas, I mixed white with yellow ochre.

I decided to enfold the building in flowering trees, instead of just letting it flow into the background. The bare branches were there; I just added soft blossoms and leaves to fill them out. I used the same colors as in the building for this, with the addition of a little permanent mauve. The right side of the building is almost completely obscured, with just an indication of a window peeking through. Thus, the viewer is aware that the building is there without actually seeing the structure. The same effect occurs in the lower left portion of the building.

I kept the colors and tones of the building and the trees similar because I wanted the background, building, and foreground to flow together; this brings a strong sense of unity to the painting.

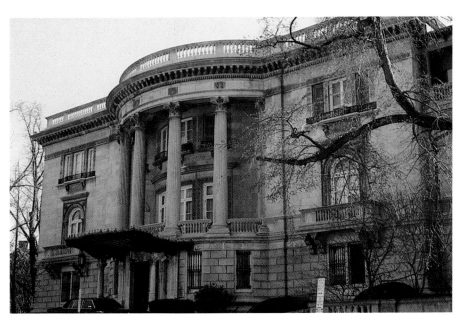

Bringing in New Colors

The reference photo for this painting is overexposed; even so, there wasn't much color in the original scene. My main problem here was to introduce the element of color in a way that would be pleasing to the eye and not appear unnatural.

My solution was to use a lot of different hues, for variety, but to keep the intensity low. The arches and facade of the church contain streaks of reds, yellows, oranges, purples, and blues, and these colors are echoed in the other areas of the church. Everything is subtle and modulated, however; none of the colors is so bright that it jumps out and dominates the others.

One technique I used to achieve this effect is mixing colors on the canvas by dragging a brush loaded with paint into an area of a different color. The dragged paint doesn't completely cover what's underneath, and the resulting color has more richness and depth than it would if it were mixed on the palette. This method works best when a light color is dragged over a darker one. The brushstroke is usually visible; in this painting, the strokes followed the contours of the building and helped define the structure.

I used a lot of red and yellow for the people, rendering them fairly loosely so they wouldn't become the focal point. I added a woman with a red hat on the right to accent the colors of the others. The purple tones were streaked into the steps and then used on the sidewalk for continuity of color. The picture needed a little green to round out the color scheme and make it come alive, so I added the small bush on the left and the overhanging tree branches at the top.

Light colors are dragged over darker tones, allowing some of the underpainting to show through. The resulting color has depth and richness; the brushstrokes help define the form.

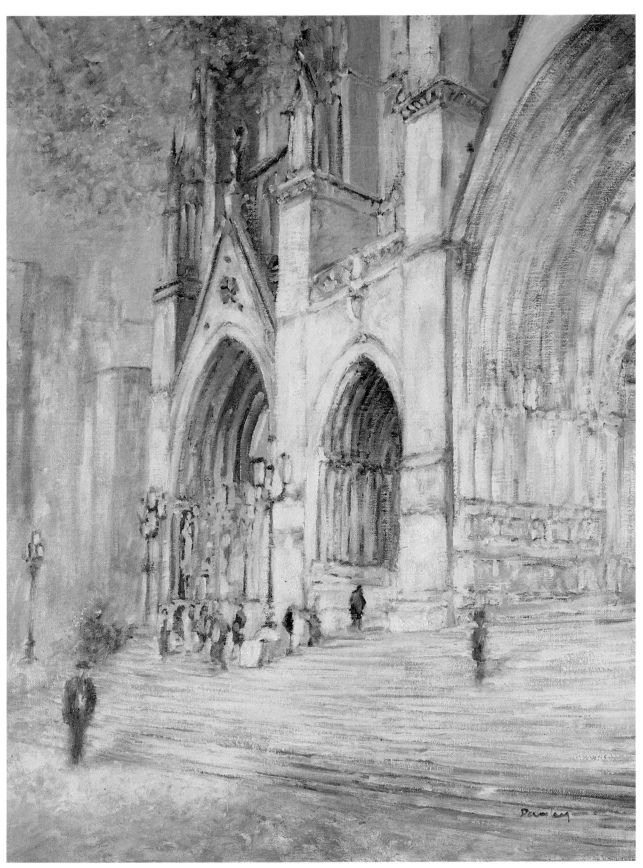

St. John's Cathedral, New York City, oil on canvas, 20″ x 24″ (50.8 cm x 61.0 cm)

Varying the Brushstrokes

The carriage, dark and solid, anchors this scene; the buildings are ethereal and dreamy —indeed, the building on the right almost seems to be floating. The colors evolved as the painting progressed, and I used different types of brushstrokes to achieve different effects.

I drew in the cathedral with ultramarine blue, then went over the features of the facade—the stones in the columns, the parallel lines and curves of the arches—with blues, greens, and yellows, scumbling and dragging the paint, usually brushing a light color over a darker one. The dragged paint is particularly obvious in the arches, where the brushstrokes define the forms.

The building on the right is much less solid than the cathedral; it's barely there. I began with a smooth underpainting of the background gray, then went over it with the light and dark areas of windows and sunlit facade. Again, the brushstroke defines the form, but this stroke is much less vigorous than in the cathedral. The value range of this area is also very narrow, so there is very little contrast.

The tree in front consists of long, flowing strokes for the branches and small spots of color for the leaves. The values are close to those of the building, so the tree doesn't come forward much, but the brushstrokes interrupt each other.

I used broken color in the steps and sidewalk, on the horse, and in the area to the right of the carriage. Values are close together, so the effect is subtle. In contrast, the street is very smoothly painted.

A number of different techniques were used on the church— scumbling, dragging, broken color. I usually applied light paint over dark areas.

The straight, vertical strokes that define the forms of the building are interrupted by the long, flowing strokes of the tree branches and the dots and dashes of the leaves.

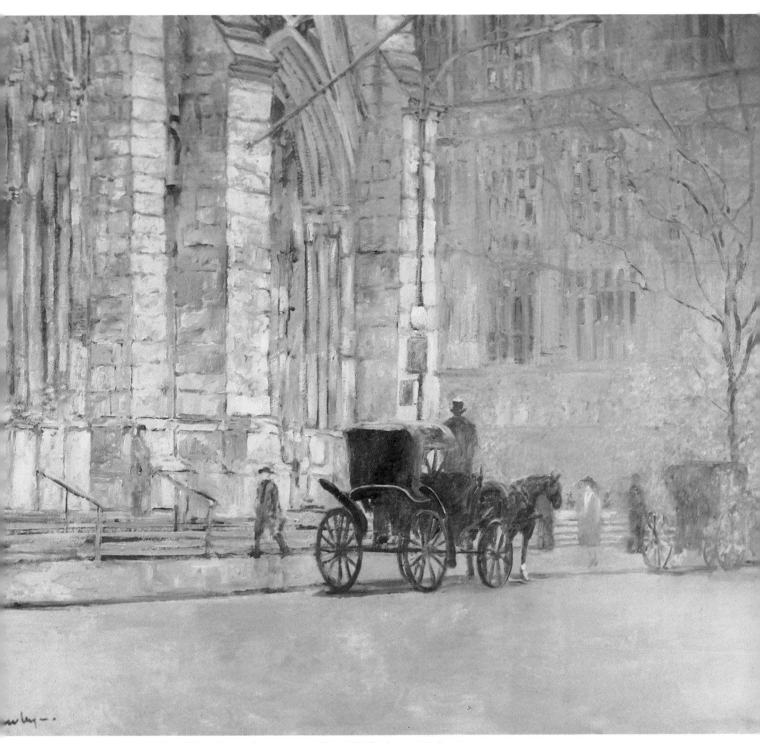

ST. PATRICK'S CATHEDRAL, NEW YORK CITY, oil on canvas, 40″ x 44″ (101.6 cm x 111.8 cm)

Index